MANGA ART
SECRETS

MANGA ART
SECRETS

THE DEFINITIVE GUIDE TO
DRAWING AWESOME ARTWORK
IN THE MANGA STYLE

DALIA SHARAWNA

Search Press

A QUARTO BOOK

Published in 2021 by
Search Press Ltd
Wellwood
North Farm Rd
Tunbridge Wells
Kent TN2 3DR

Reprinted 2022 (twice)

ISBN: 978-1-78221-980-4
ebook: 978-1-78126-976-3

Conceived, designed and produced by
Quarto Publishing plc
The Old Brewery
6 Blundell Street
London N7 9BH
www.quartoknows.com

QUAR.340666

Project editor: Anna Galkina
Copy editor: Katie Hardwicke
Designer: Josse Pickard
Illustrator: Dalia Sharawna
Deputy art director: Martina Calvio
Art director: Gemma Wilson
Associate publisher: Eszter Karpati
Publisher: Samantha Warrington

Printed in China

CONTENTS

MEET DALIA!

I am Dalia, an artist based in Hebron, Palestine, and known on Instagram as @drawing_dalia.

When I was a kid, I used to watch anime all the time, drawing my favourite characters with a passion. This evolved to drawing manga characters of my own. I still use references to aid me in drawing and people who follow me on Instagram know that I love using K-pop artists as my main source of inspiration.

My drawing skills weren't that great at first, but I kept practising to reach the level that I am at today. I am happy with what I have achieved so far, but feel I still have lots to learn. I always practise hard, trying out new drawing techniques. For that reason, I believe anyone can draw if they are passionate about it and there's always the potential to improve – the more you practise, the better you get!

I am an emotional person and love that drawing is one of the best ways to express my feelings. If someone can look at my drawings and relate what I have tried to express to their own emotions, then I'm very happy.

Communicating through images, using a line rather than a word, means that you can cross any language barriers, making it a truly universal way to reach people. I have gained followers on Instagram from all around the world. I am so glad that my account is a place where people with the same interests as me can share ideas and connect with each other. I hope that I can now share some of my skills and knowledge with you and let you in on my personal manga secrets.

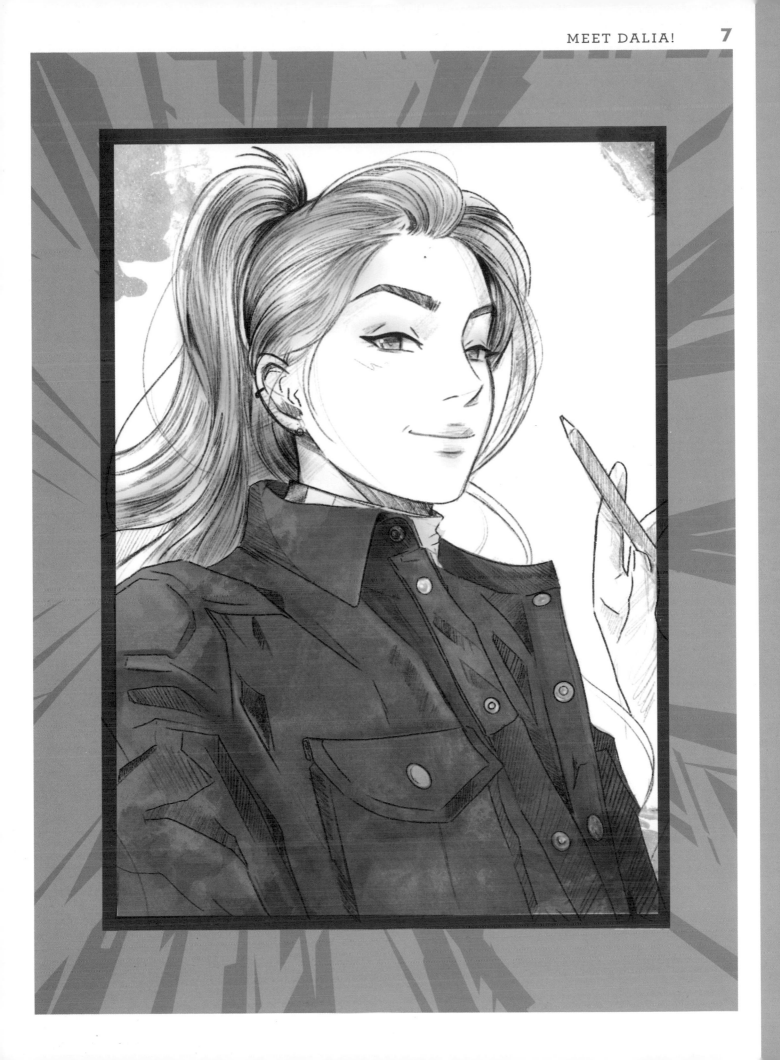

TOOLS FOR DRAWING

Before you begin creating your manga character you'll need to prepare your drawing equipment. I started out with a standard 2HB pencil that we used at school, and worked on printer paper and, while I have a few more pencils now, I still don't believe that investing in expensive tools is necessary. Good tools help in drawing but you can still achieve great effects without spending a fortune – invest time rather than money, learn the right drawing techniques and principles, and keep practising!

Paper

You can draw on any paper, and there is a whole range to choose from that varies in thickness, texture and colour. I tend to use standard 110gsm weight paper, which is somewhere in the middle of the quality range. The surface is smooth and the pencil can move easily. I like to use a small A5 sketchbook so that I can carry it with me everywhere. But other sizes may suit your style, so explore what is available.

A sketchbook is ideal for when the mood strikes and you want to catch a pose or idea quickly, or for developing a character's style. Work up final drawings on loose sheets of paper.

Pencils

The hardness of a pencil lead determines the type of line and tone that it makes, and this is graded on an HB scale from the palest, hardest grade – 9H – to the darkest, softest grade – 9B. In the middle, between HB and H, is F, and this is the grade that I like to use in a mechanical pencil for outlines. This produces light lines that I can erase without leaving a trace or making the sketch dirty. I then use HB, 2B and 8B pencils to go from light to dark. I use the 8B pencil less often but when I do, it allows me to reach very intense, dark shades similar to a black ink pen. Try various pencils to find the preferred hardness that suits you.

Coloured pencils are a great tool for adding colour in controlled ways, plus why not try using watercolour pencils – these are great for light washes of colour when you add water with a brush.

Eraser and sharpener

As well as removing any errors, an eraser is also essential for lifting off your light guidelines as your drawing progresses. I like to use two erasers in different sizes: a large, soft or putty eraser that you can shape to make changes in outlines, and a smaller, harder size with defined edges to make precise corrections. Avoid using erasers that leave coloured marks behind. A pencil sharpener is a handy tool to have in your kit, too; I prefer to use a well-sharpened pencil for precision.

Templates

I don't use templates very often, but they might be helpful for a beginner when creating the guidelines for a drawing.

Chapter One
DRAWING FACES

The face is one of the most important parts of the character when drawing manga. It determines personality and guides the style for the rest of the drawing. Starting with the face and hair means you can customize your character through subtle changes in their facial features or expressions, exploring aspects of their style or personality to give them individual characteristics that differentiate them from others. With practice and patience, you will soon have captured the essence of your manga character in just one look.

DRAWING FACIAL FEATURES

When drawing any face, getting the position of the facial features right is the key to success. Starting with a front view, follow the steps below using guidelines to help position the eyes, nose and mouth. Once you've got the hang of where to place the key features, you can build the details in a manga style to add expressions and emotions (see pages 30–33).

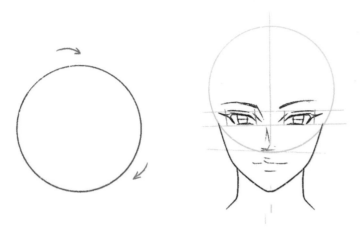

1 Draw a circle. The circle will be a guide for building the whole face and represents the top of the head and the upper portion of the face. Try drawing the circle freehand; it doesn't need to be completely accurate and with drawing, like most other things, practice makes perfect.

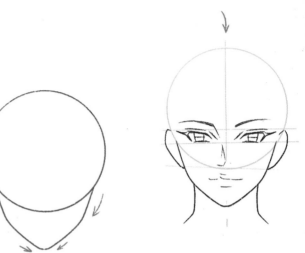

2 Add the jaw. In a front view the jaw will be symmetrical. Draw a vertical line through the circle, dividing it in half. Extend the line beyond the circle to where you want the chin to end. The line can vary in length; usually the longer the chin, the older the character. Draw the side of the face down to the chin on each side of the line, starting at the edge of the circle and stopping at the end of the extended line.

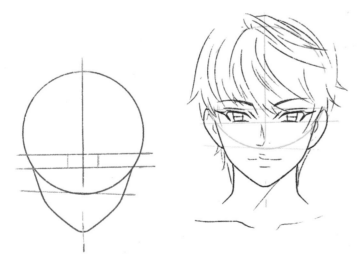

3 Add guides. Divide the face to help position the eyes, nose and mouth. Draw horizontal lines roughly a third of the way up from the bottom of the circle to place the eyes. Mark the top and bottom of the eye. Draw a line across the bottom of the circle to mark the end of the nose. The space between the eyes equals the width of one eye.

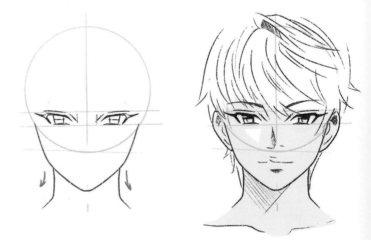

4 Add the neck. This helps to correctly position the head on the body. Extend the guideline at the base of the nose to the sides. From here, draw lines from the chin that are slightly curved, imitating how the neck joins the shoulders. Keep the lines symmetrical to balance the head.

MANGA ART SECRET

Guidelines are not just for beginners – the majority of the artists I know use guidelines to draw. They help to make your drawings more accurate and better proportioned.

DRAWING FACES: SIDE VIEW

By breaking the head and face down into stages, using guidelines to place the key features, you can draw a character from any viewpoint. Looking from a side view simply means that you draw the features in profile, keeping to the same principles of positioning the elements in relation to the simple circle that you take as your starting point. At this stage, don't worry about details; just nail the basics first.

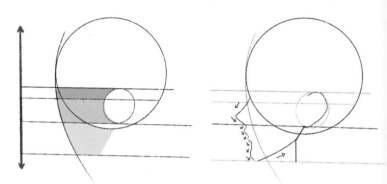

1 Draw a circle. Start by drawing a circle to represent the top portion of the head. Draw a smaller circle for the ear position in the lower half of the larger circle. Now add a curved line to help you determine where to start and end each of the face components.

2 Establish proportions. Divide the face into sections to help place the features. The eye is placed in the darker top band; the nose in the middle band; and the mouth and chin in the lighter band. If you angle these lines you can adjust the placement so that the face is tilted up or down.

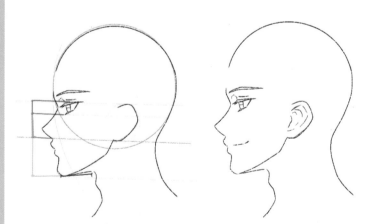

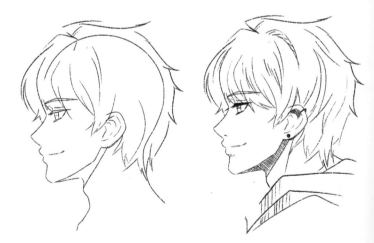

3 Add features. Using the sections marked in Step 2, and the curved line from Step 1, you can draw the profile of your character's face. Starting from the base of the eye, draw in the curve of the nose, extending outside the curved guide and returning to the central line, level with the ear. Add the lips and chin, bringing the line of the jaw back to meet the base of the circle at a central point. Add an eye to correspond with the darker band and a suggestion of lips, and the face suddenly comes to life.

4 Build detail. Now that the basic elements of the face and head are in place – the eyes, nose, mouth and ears – you can add more detail and practise small adjustments, such as changing the angle of the head, the tilt of the chin and changes in expression. See the following pages for tips on how to draw these details.

MANGA ART SECRET

Always start drawing the face from the top to the bottom as it will make the curves much smoother. One trick is to leave space between the chin and the neck. This space varies in size depending on the face angle; the shorter it is means the character face is straight and not leaning towards an object.

Tips for drawing the jaw and chin

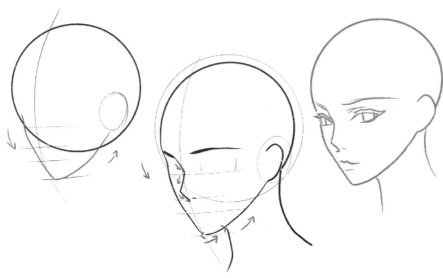

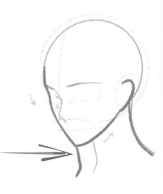

Avoid making the jaw too pointy and triangular. Always round the chin with natural curves.

Try not to join the neck to the chin; keep them separate to define the head.

MANGA ART SECRET

The facial features on the side that the character is leaning or looking towards are larger than those on the other side. This is because of depth and perspective, which must be considered when drawing faces from an angle other than the front and the side view.

DRAWING FACES FROM DIFFERENT ANGLES

Now that you are familiar with the basic starting points for drawing any manga face, you can begin to explore drawing the head from different angles to give your character more expression. To help, when reading your favourite manga or watching anime, try to visualize the guidelines on the faces, noting the proportions and angles. Try these exercises to build up templates so that faces will start to come naturally as you progress.

Start here.

1 **Always start with your guidelines.** The number of guidelines is the same when drawing a face at an angle. A circle for the top portion of the head, a circle for the position of the ear, and guides for the nose and eyes.

2 **Include the whole jaw.** Many people tend to overlook this point, especially when they are planning to eventually cover the jaw with hair or clothing. However, it is an important element in the proportions of the face and will help give the head the correct orientation, and help you to place components correctly. Use the curved line to establish the degree to which the head is turned.

With just a slight tilt the head can convey a range of emotions, from sorrow to defiance.

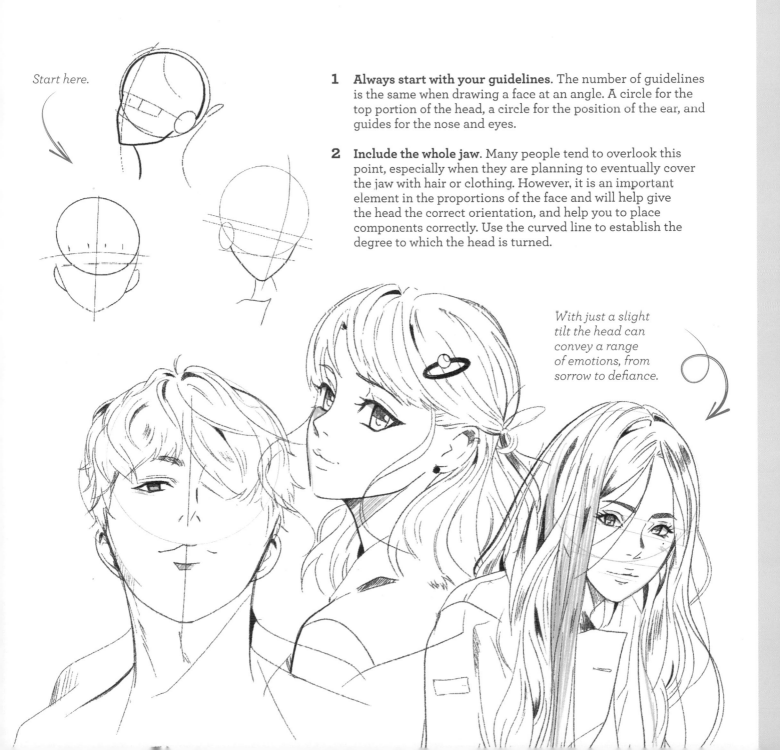

MANGA EYES: BASICS

My favourite part when drawing a manga character is drawing the eyes. Through the eyes you can communicate in a way that even words can't. In manga, eyes are the most prominent feature of the face. They show character and reveal emotions such as fear, anger and happiness. You can create a whole personality just in the way that you draw your character's eyes.

Eyebrows and eyelashes add instant character, framing the eyes and hinting at beauty.

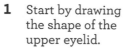

1 Start by drawing the shape of the upper eyelid.

2 Thicken the shape by drawing a matching line underneath, connected together at the ends.

3 Now with a much lighter line, draw the lower shape of the eye. Connect the two shapes in a corner of the eye, to make a simple outline.

4 Now draw the iris. In simple eyes this can be an oval shape with either the top or bottom of the oval covered by the lids.

5 Add the pupil. The pupil position will depend on where the character is looking.

6 Add the final touches to complete the eye outline, including eyebrows and lashes.

MANGA ART SECRET

When shading in the iris, try to hatch in one direction with strokes that fill the shape. Rather than a solid colour, create a gradient of tone, making the upper side of the iris, beneath the lid, darker and then fading in the lower half towards the bottom lid.

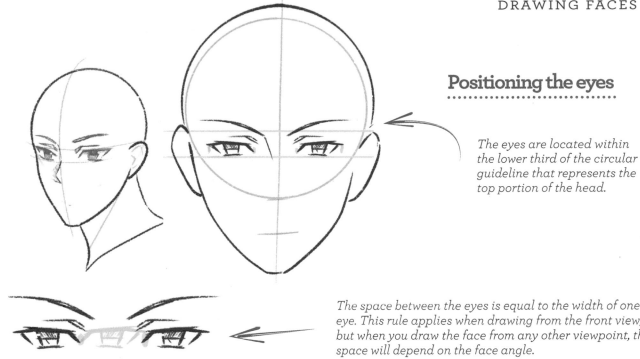

Positioning the eyes

The eyes are located within the lower third of the circular guideline that represents the top portion of the head.

The space between the eyes is equal to the width of one eye. This rule applies when drawing from the front view, but when you draw the face from any other viewpoint, this space will depend on the face angle.

You can choose from a number of styles to draw manga eyes, varying in detail and difficulty. For beginners, start with styles that are simple and less detailed. These are often wide open, larger eyes without shading or a pupil. As you become more confident, add small details to the iris, such as shading, highlights of light that give sparkle, or a more pronounced pupil. Eye size also varies depending on the character: usually, girls' eyes are rounder and softer than boys', which have defined edges. Try various styles or even combine elements from different styles to see what you like.

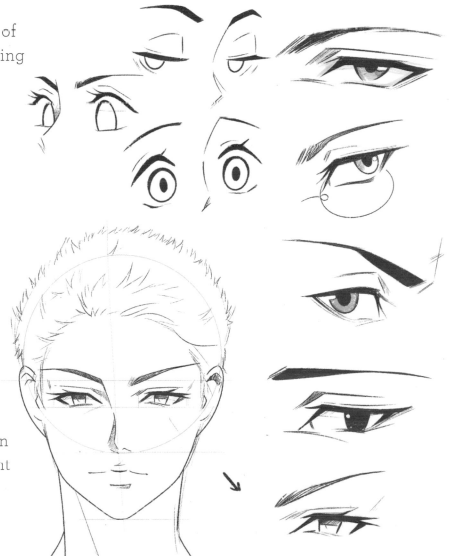

MANGA EYES: EYELASHES AND EYEBROWS

Eyelashes and eyebrows complete the eyes. They can be just a simple line to frame the eye, but you can use them as a tool to help show the emotions of your character, too. In some styles, eyelashes are only drawn for female characters. However you use them, they add beauty to the eyes and make them look more complex.

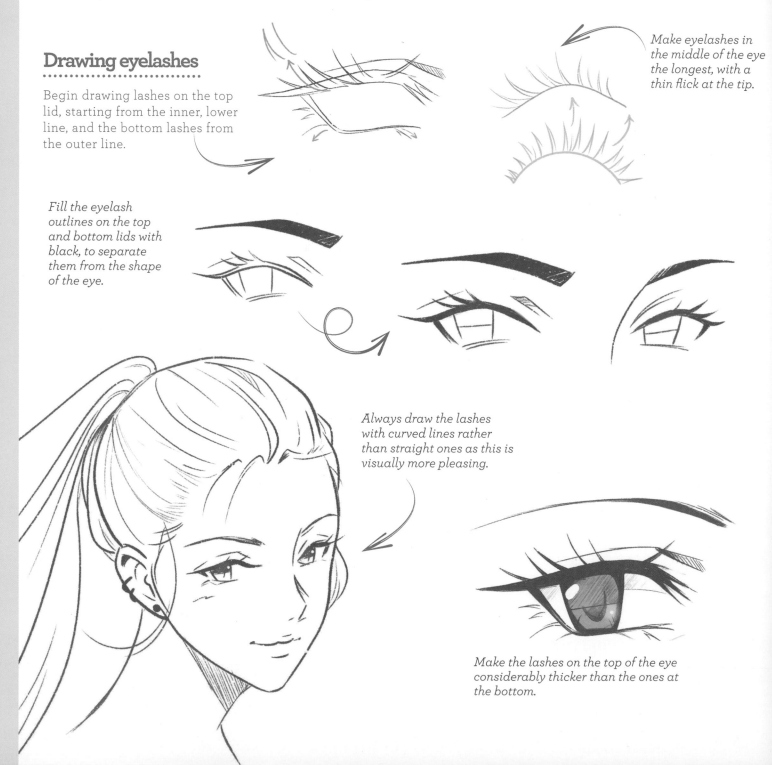

Drawing eyelashes

Begin drawing lashes on the top lid, starting from the inner, lower line, and the bottom lashes from the outer line.

Make eyelashes in the middle of the eye the longest, with a thin flick at the tip.

Fill the eyelash outlines on the top and bottom lids with black, to separate them from the shape of the eye.

Always draw the lashes with curved lines rather than straight ones as this is visually more pleasing.

Make the lashes on the top of the eye considerably thicker than the ones at the bottom.

Lighter shading on the upper edge gives a realistic shaping without the brow looking heavy.

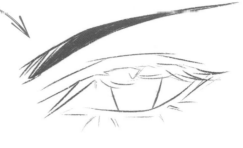

Drawing eyebrows

Eyebrows are fairly similar to eyelashes. Depending on the style, they can be quite simple and drawn with just a single line or they can be drawn with individual strokes to give a more complex look.

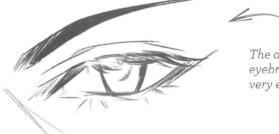

The angle of the eyebrow can be very expressive.

1 Draw a lightly curved line that represents the bottom of the eyebrow.

2 Add the top of the eyebrow, making it thicker at the inner end. Vary the shape of the eyebrow to indicate an expression, such as an arch for surprise.

3 Add strokes for hairs at the beginning of the brow to soften the boxy and geometric look.

4 Fill in with black and leave the hairs you added still separated, creating a finished shape.

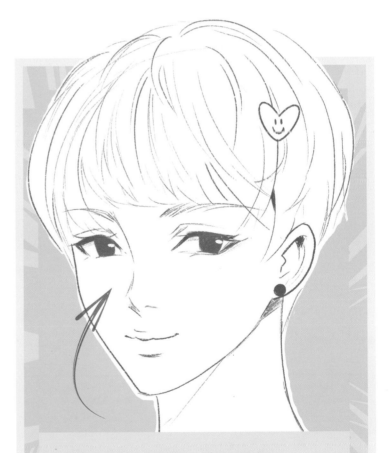

MANGA ART SECRET

Before filling with colour, draw a circle to add sparkle to the eye. As well as adding beauty, this also helps to make the character appear as if they are looking in the direction you want them to.

MANGA EARS

Once you've mastered the basic ear shape following the step-by-step guide below, you can use it for any gender and many different characters. As a facial feature, the ears are often partially hidden by hair but they can be used to add personality to your character, embellishing them with accessories, such as piercings and jewellery, or adding earphones.

Drawing ears

Follow the sequence of steps below, keeping your lines fluid and avoiding sharp edges or angles, which make the ear look geometric. Make the lines smooth and simple, working from the outer shape inwards and adding the inner details as simplified shapes that add a 3D quality once they are shaded.

Drawn from the front, the basic shape can be changed by elongating it or rounding it out.

Positioning ears

When drawing from the front, use guidelines from the top and the bottom of the ear to help you place the ears symmetrically and keep the face balanced.

Adding detail to ears

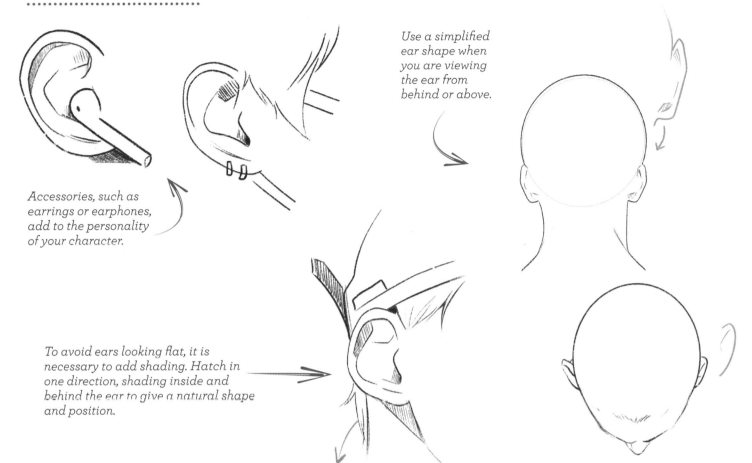

Accessories, such as earrings or earphones, add to the personality of your character.

Use a simplified ear shape when you are viewing the ear from behind or above.

To avoid ears looking flat, it is necessary to add shading. Hatch in one direction, shading inside and behind the ear to give a natural shape and position.

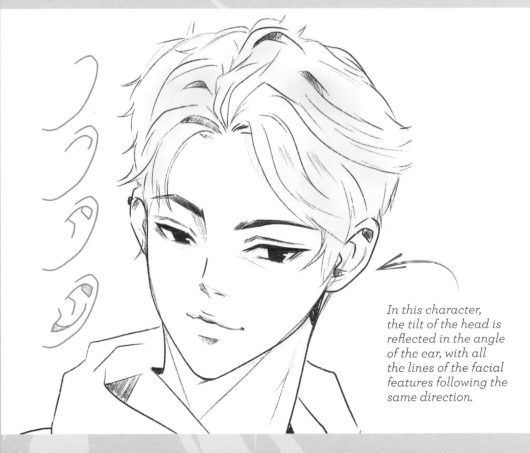

MANGA ART SECRET

In young characters, the ears are usually drawn large and often visible beneath the hair. For older characters, the ear is lengthened.

In this character, the tilt of the head is reflected in the angle of the ear, with all the lines of the facial features following the same direction.

MANGA NOSES: MALE

In manga and anime styles, the nose tends to be simplified to a line or dash, with little detail or shading, keeping the focus on the eyes. Getting the nose right depends on its position and accurate proportions, taking into account the viewpoint and whether your character is male or female. Here and on the next page, we look at noses in a variety of styles and orientations.

MANGA ART SECRET

The way you draw a nose can give a character lots of personality. You can also show age with a slightly larger nose or develop your own nose style for your characters.

Noses from front view

Using the guidelines for the face on page 12, draw a line with a slight curvature, following the central dividing line to the base of the circular guide. This represents the bridge of the nose. Add the suggestion of the tip and nostrils with light shading, then hatch on one side to suggest a shadow.

The shape is clearer in profile.

Noses from side view

When drawing the nose from the side view, the bridge of the nose will break out from your circular guideline and be strongly defined. Add shadow just on the tip of the nose.

Noses from different angles

Like the front view, the nose will still fall within the circular guideline when the head is turned. Cast the shadow on the side of the nose that is turned away.

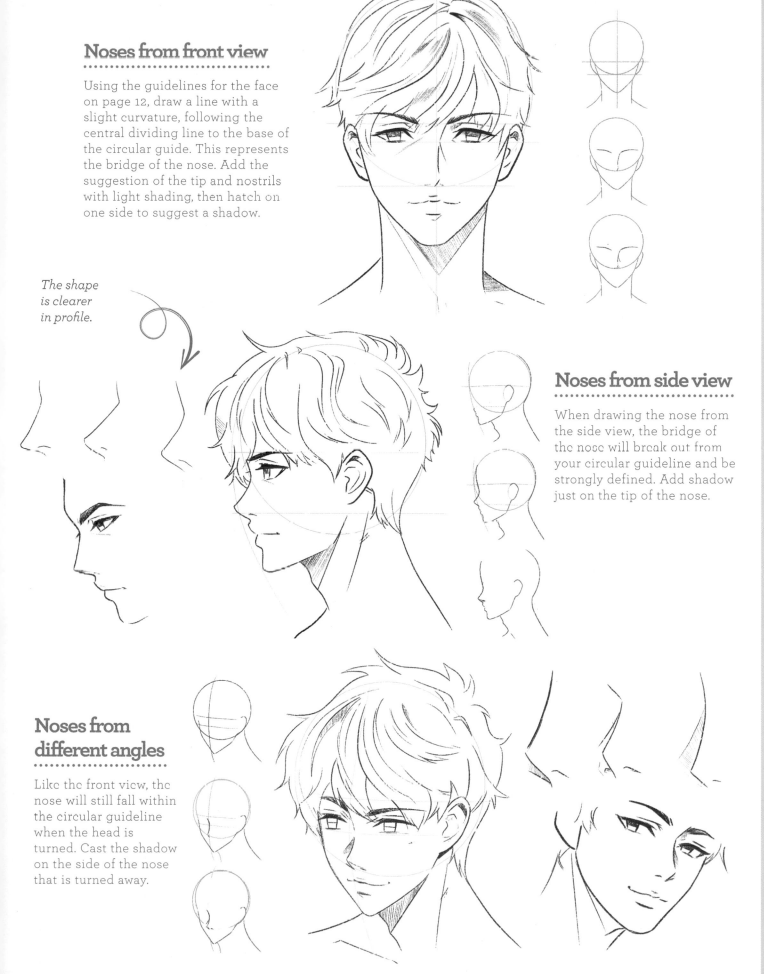

MANGA NOSES: FEMALE

Usually, noses in manga are drawn in less detail when compared to other drawing styles and tend to be small and pointed. Female noses are even more simplified than male ones, and features such as nostrils are likely to fade out or not be drawn at all.

Noses from front view

The principles for adding a nose on the front view for a female character are similar to those for a male (see pages 24–25). A very light line is all that is needed to indicate the bridge of the nose, extending from the end of the eyebrow. This area can be shaded to give definition to the eye socket.

Noses in profile

Using the circular guides and the curved line to establish the proportions of the head (see page 14) will help you place the nose from the side. Female noses tend to be short with a pert or angled tip.

Noses from different angles

Placing the nose within the circular guide, note the change in angle of the central line and use this to position the nose so that it matches the tilt of the head. A light shadow will anchor the nose.

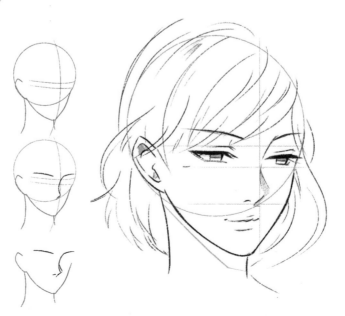

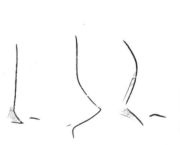

Try different profile shapes to suit your character.

MANGA ART SECRET

Try using a softer pencil or lighter line to give the nose a more feminine appearance. When it comes to drawing manga, the eyes, not the nose, are the most prominent feature on the face.

MANGA MOUTHS

What is so interesting about drawing a mouth is the expressions that you can give your character. In manga, mouths tend to be smaller than in real life, often simplified to just a single line so as not to detract from the eyes. With extremes of emotion, the mouth is larger and exaggerated to convey happiness, anger or excitement. The key is to over-simplify, starting with a line and adding lips or teeth only when they add to your character's story.

Using mouths to create expressions

For an accurate expression, look at the mouth in real life and break down the elements to a few lines. Start with the top line of the lips and work down.

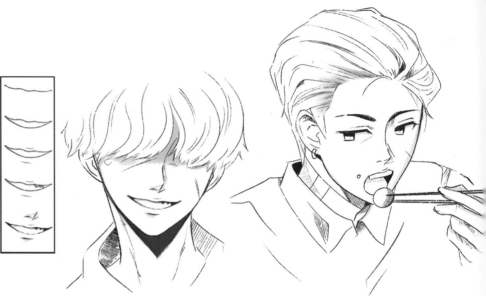

A smile can be conveyed in just a few lines. Start with a very simple upper line, just turned up at the ends. Add the lower line that defines the strength of the smile and just a suggestion of the nostrils and chin.

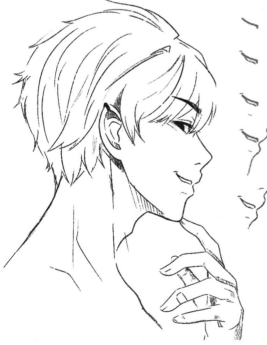

Including the teeth or a tongue can result in a dramatic expression.

MANGA ART SECRET

In some manga styles, female lips are drawn with a more realistic style. This will make your character look more feminine and beautiful at the same time. Use darker shades to represent a dark lipstick colour.

Neutral facial expression

When mouths are drawn in a more realistic style with a neutral expression, start with the line that separates the upper lip from the lower one. Then add the central shapes of the upper and lower lips.

Generally, the upper lip is smaller than the lower one, which you can indicate by drawing it closer to the central line. Finally, add a shade to indicate the colour of the lips that matches your drawing.

FACIAL EXPRESSIONS

To help your drawing communicate thoughts, ideas and, most importantly, emotions, you need to capture how the whole face and even the angle of the head work together. See the examples below for how to match an expression across all the facial features.

Using guidelines to create expressions

Some emotions lead to slight shifts in the guidelines that we looked at on page 12. Make sure that the placement of the eyes follows the angle of the head on both axes.

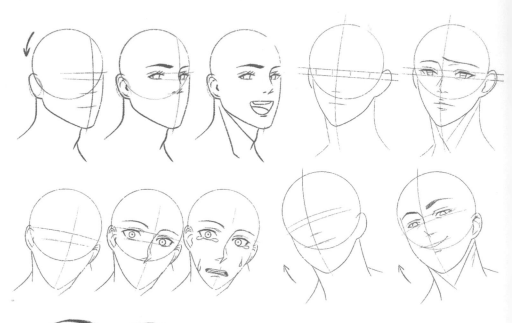

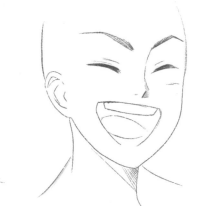

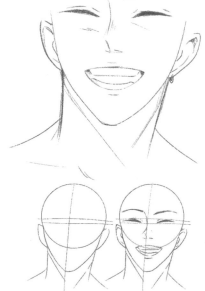

Drawing a happy expression

When drawing a happy expression, you can draw the eyes open or closed, depending on the level of happiness you want to show. You can add tears of joy to show when the character is in an extreme state of happiness.

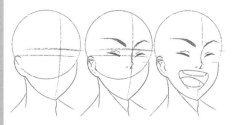

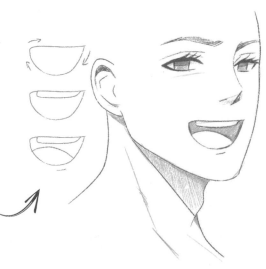

The mouth plays a key role in expressing happiness. Look at the sides of the mouth; they are curved slightly upwards like a hanging chain, even when the character is laughing and his teeth are showing.

Drawing a sad expression

A sad face and pose are reflected in a downward turn of the eyebrows, eyes and mouth. Adding tears is a simple device to show sorrow and heartache.

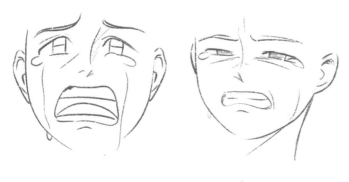

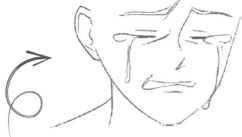

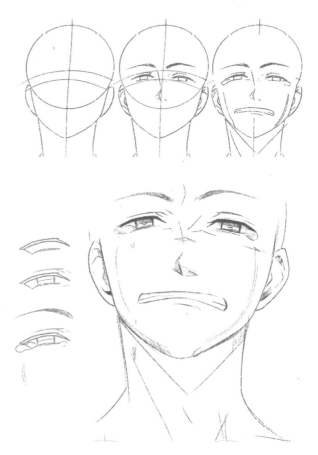

Eyebrows are very expressive, so make sure that you match their position according to the degree of sadness you want to capture.

Check the shape of the eyes when a character is crying; they could be closed or squinting.

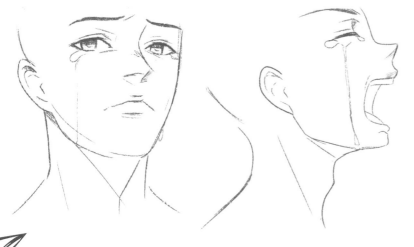

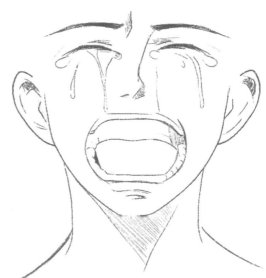

A sad mouth will be the exact opposite to a happy expression, with the sides of the mouth slightly curved downwards like an arch. An exaggerated, open mouth indicates a wail when combined with closed eyes.

FACIAL EXPRESSIONS: MORE IDEAS

Expressions in manga are as wide and varied as expressions in real life. Remember that eyes, eyebrows and mouths are really important. Changing them can make the character look happy, sad or even neutral.

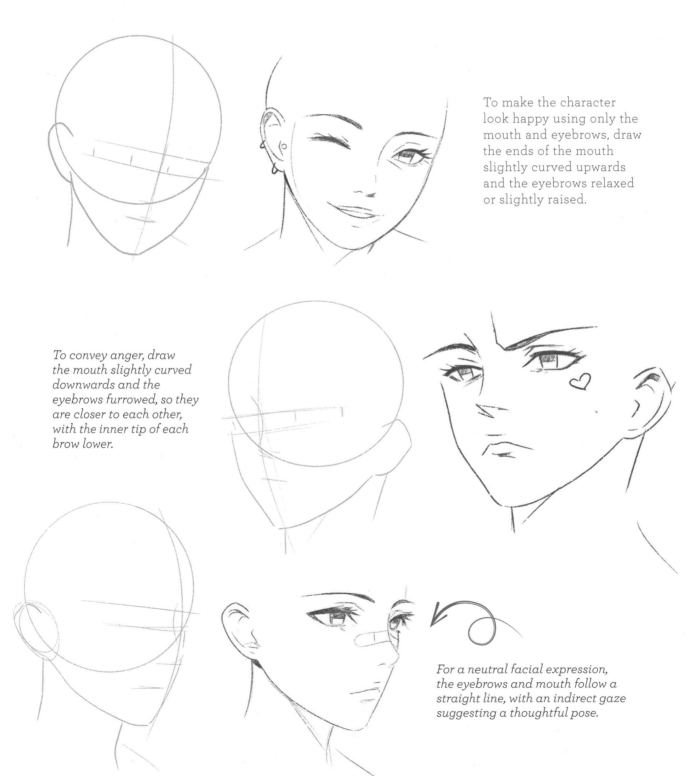

To make the character look happy using only the mouth and eyebrows, draw the ends of the mouth slightly curved upwards and the eyebrows relaxed or slightly raised.

To convey anger, draw the mouth slightly curved downwards and the eyebrows furrowed, so they are closer to each other, with the inner tip of each brow lower.

For a neutral facial expression, the eyebrows and mouth follow a straight line, with an indirect gaze suggesting a thoughtful pose.

MANGA ART SECRET

Different artists draw emotions and facial expressions in different ways. I tend to draw male characters with more prominent facial expressions compared to their female counterparts, where I try to have a more settled look, like the girl below. It will all depend on you and your drawing style, and as long as you understand how different components of the face respond to different expressions, you can easily communicate what you want your drawing to express.

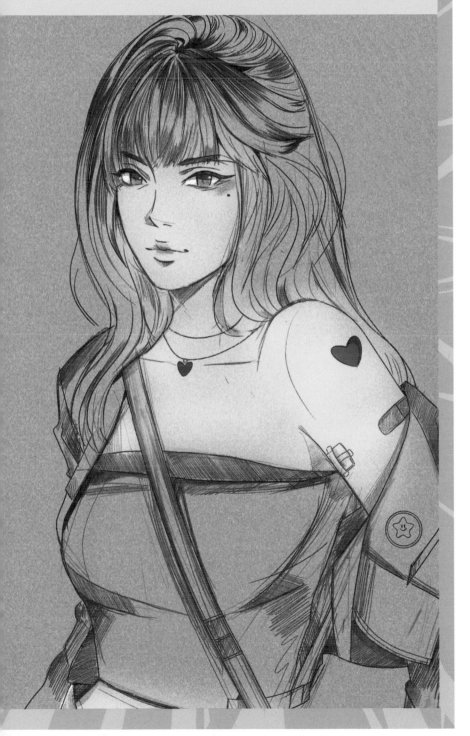

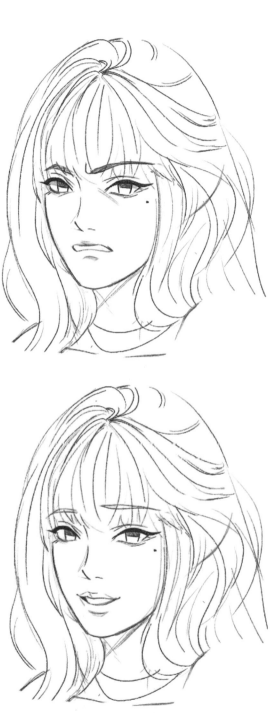

These illustrations demonstrate how a simple change in the line of the eyebrows and mouth change this character from angry to happy.

Draw the ear in four stages. You can then adapt or accessorize the basic shape (see pages 22–23).

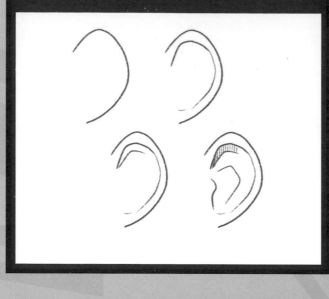

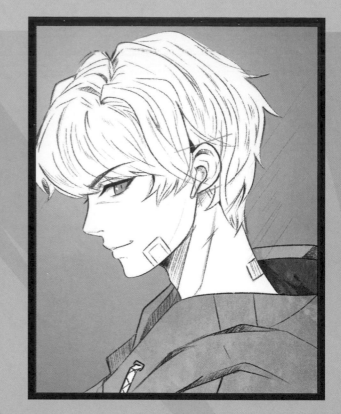

EXERCISE ROUND-UP

At this stage you should have a good understanding of the general principles of drawing manga faces. Follow these quick exercises to practise further, concentrating on drawing each element separately before combining them to create a character unique to you.

Take your time to perfect manga eyes. Break them down into stages; refer to pages 18–21 for variations.

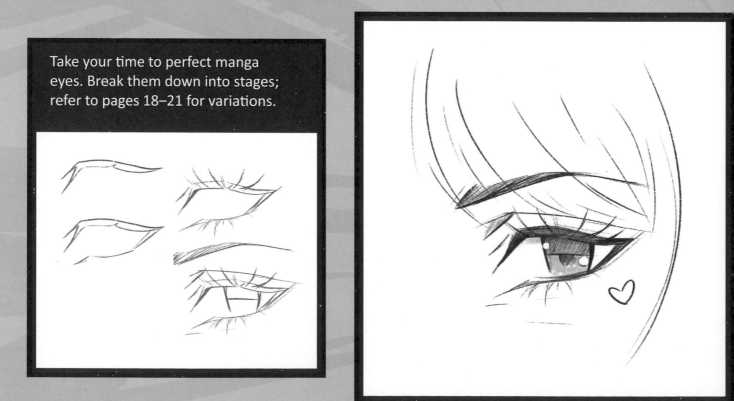

Fill in the facial details of the face below, using the appropriate proportions; see pages 12–13. Try different expressions by varying the direction of the gaze.

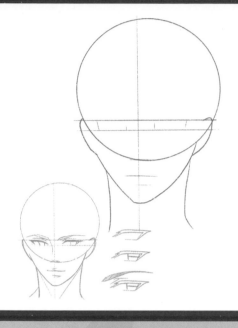

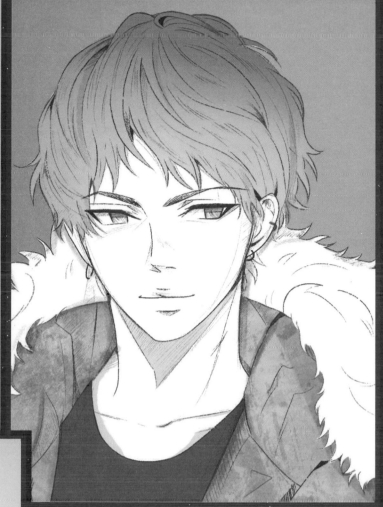

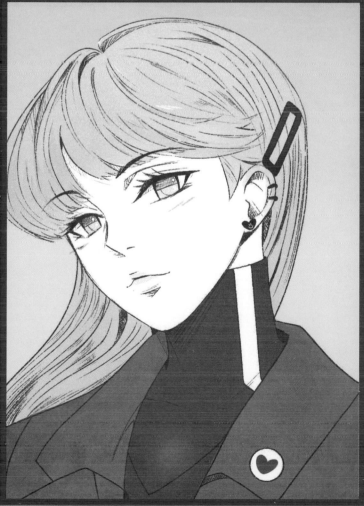

Adapting the angle of the head changes the profile and is worth practising to give you a wider range of expressions and poses that will add to your character development.

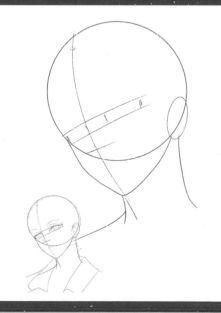

JENNIFER (@VHOXNIHILIS)

I'm Jennifer Voigt, a freelance artist based in Germany. I work mostly digitally, with Procreate® for iPad, which is a fun program that rewards experimentation. The process of drawing and its unpredictability are always inspiring, and I love to draw quirky characters and creatures. The cat with no claws and the cat with headlights for eyes (opposite) are two creatures that I drew for personal projects. The character below represents joy, and was created for a character design challenge on ArtStation, based on emotions.

MANGA ART SECRET

When it comes to creating confident line art, my secret is to really trust your intuition and let loose when drawing the line. Even if you have to repeat it a few times, the perfect line will eventually appear.

Chapter Two
DRAWING HAIR

The hairstyle that you decide to use when designing your manga character plays a huge role in showing their personality. You can use the shape, style and colour to reveal several things about your character; for example, bright-coloured hair with waves suggests a bouncy, fun-loving, warm-hearted personality, while a short, cropped style might suggest determination and strength.

You don't need to follow conventional rules – hairstyles in manga characters are not affected by gender and, in the manga world, there is a huge diversity in terms of style. You can take your inspiration from real life, where girls tend to have longer hair than boys, and if your character is from an historical era, you can match their hair to the period to give authenticity. Long, short, straight or wavy, try any option and see what effects you can create.

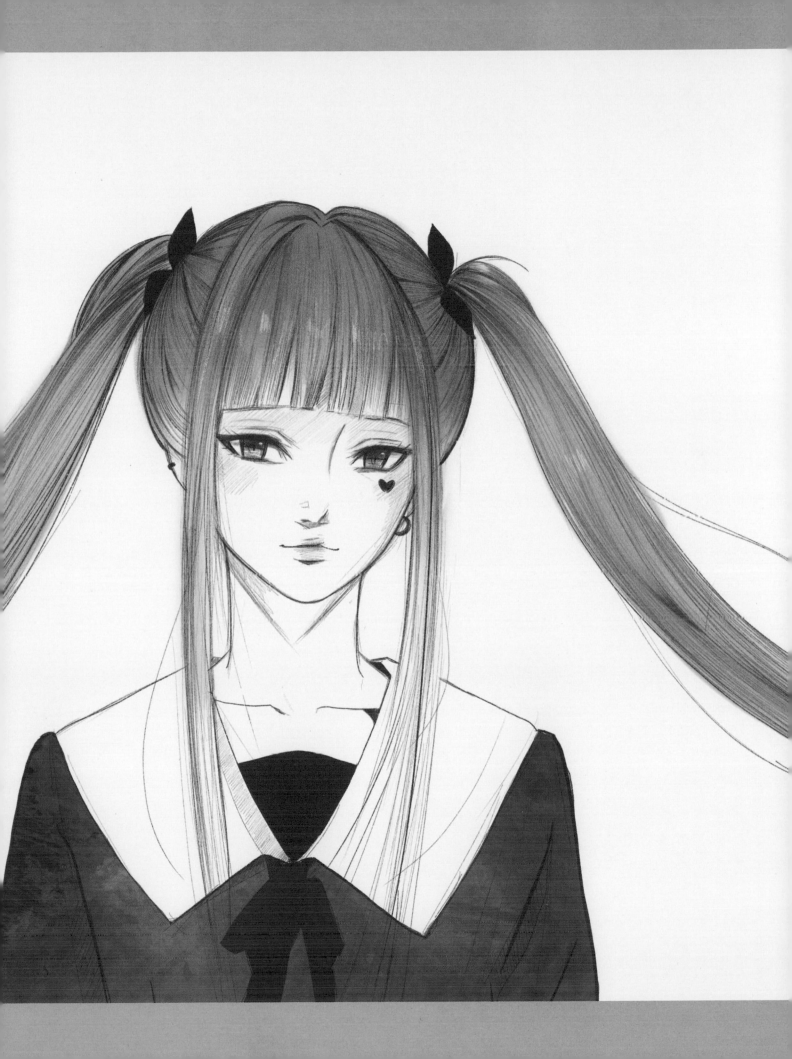

MANGA HAIRSTYLES: SHORT

Hair comes in various shapes, lengths and forms, which can make it seem difficult for the beginner. However, manga artists have developed methods for simplifying hair. For animation, hair is drawn in sections and this helps to break it down into manageable stages.

Drawing short hair

1 **Start with a bald head.** This helps to determinine the hair volume and reduce the chances of having unproportioned thick or thin hair.

2 **Establish volume.** To determine the volume of hair, start with an outline that simplifies and follows the shape of the head. From this curved line above the head, connect lines that show the general hairstyle and its length, keeping to the outline of the head shape. Now that the general shape of the hair is in place, you can add more volume to create a style.

3 **Add direction.** It's quite important to determine the direction in which the hair is going to flow and whether it's in one or more directions. Once you've decided, add curved lines that split the hair into sections. Keep adding lines to create more detailed strands of hair. To finalize the outlines, fill in between the sections of hair you have created with lines. This will make the outline look more detailed.

Drawing a medium-length fringe

1 Add the hairline. Start with just the head shape. Add the hairline of the character, as this helps you judge the appropriate length of the fringe, even though it's eventually going to be covered.

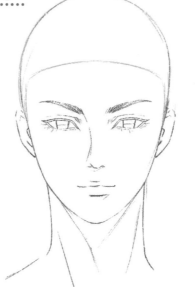

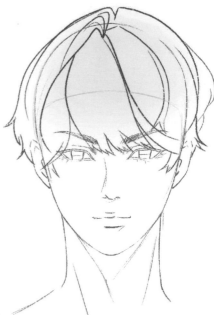

2 Outline sections. Draw the outer line to establish volume and length. Divide the hair into sections that will create the main strands of the hair and fringe.

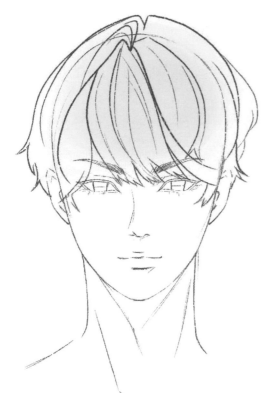

3 Add detail. Draw loose, individual strands in the main sections, with some height here and there to add volume and bounce. In shorter hairstyles like this one, it is totally fine if the strands of hair overlap occasionally. Always draw the lines that define the strands of hair according to the flow of hair. When drawing the fringe, add variations in the length of the strands of hair. This will make the hair look more dynamic.

MANGA ART SECRET

When drawing hair, avoid using very straight lines as this will make the hair look unnatural. Use gentle curves instead, following the shape of the head and occasionally changing direction to suggest movement.

MALE HAIRSTYLES

Even in short hairstyles, it is important to give a sense of movement to the hair. To draw the hair in a more professional way, adapt the flow and direction according to the angle of the head or pose, and create movement in individual strands.

Rather than showing each individual strand, practise drawing a section of hair to give it substance and weight. Draw sections that follow the direction of the head, whether forward, back or down, depending on head movement.

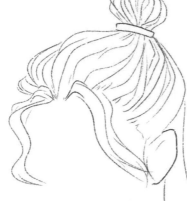
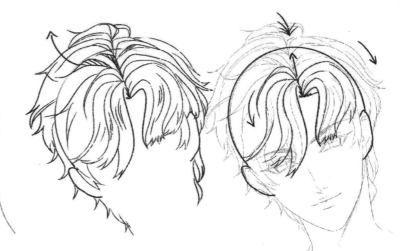

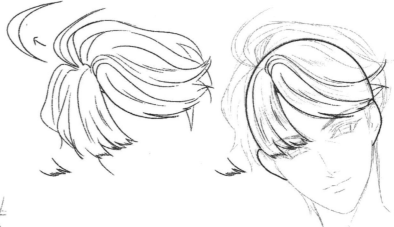

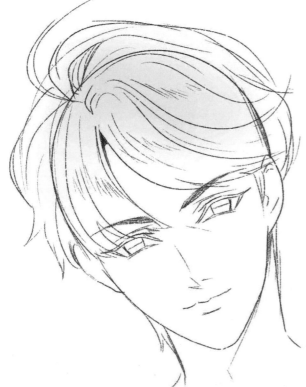

To show the effects of a breeze or wind on the hair, draw lines that represent the hair flow following the wind direction. Once the direction is established, join the lines to make strands of hair, varying the shape and length to give volume to the hairstyle and picking out individual sections that have been blown away.

Drawing hair from the side

Some male hairstyles mix long and short, with a cropped style that closely follows the shape of the head. This is best shown from a side view, contrasting with long layers on the top to show a difference in volume.

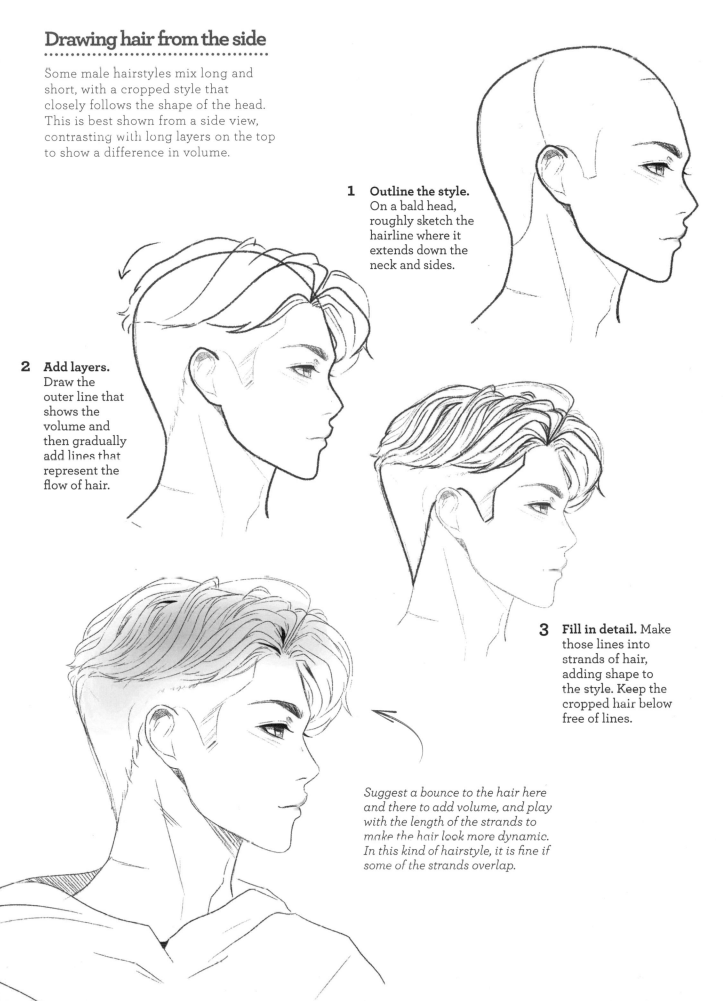

1 Outline the style. On a bald head, roughly sketch the hairline where it extends down the neck and sides.

2 Add layers. Draw the outer line that shows the volume and then gradually add lines that represent the flow of hair.

3 Fill in detail. Make those lines into strands of hair, adding shape to the style. Keep the cropped hair below free of lines.

Suggest a bounce to the hair here and there to add volume, and play with the length of the strands to make the hair look more dynamic. In this kind of hairstyle, it is fine if some of the strands overlap.

MALE HAIRSTYLES: INSPIRATIONAL IDEAS

The way the hair is drawn can be quite different from one artist to the other, with some simplifying it more and others adding lots of detail. Whatever style or length of hair you want to give your manga character, the key is to always start with the correct shape and size of head. The shape of the head is quite similar across people of different genders or ethnicities, so it is a perfect starting point for developing an accurate drawing. Never skip drawing the head, even if it's eventually going to be hidden with hair. The shape of the head will look slightly different from different angles, and it is important that you reflect this in the direction of hair flow.

The long fringe follows and highlights the tilted angle of the head.

Characterful hair

Give hair some personality! Sweeping fringes, side partings and ponytails don't just suit female characters and can be used to good effect to accentuate a pose.

Long hair on male characters is often held in a ponytail or bun, making for an interesting feature when seen from the side.

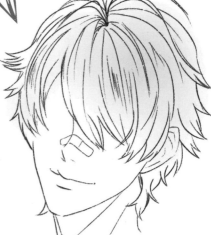

MANGA ART SECRET

A common theme is the thickness and movement of a full head of hair. Male characters often have a healthy head of hair, with long fringes or swept-aside partings, so incorporate these whenever you can, even from a side or back view.

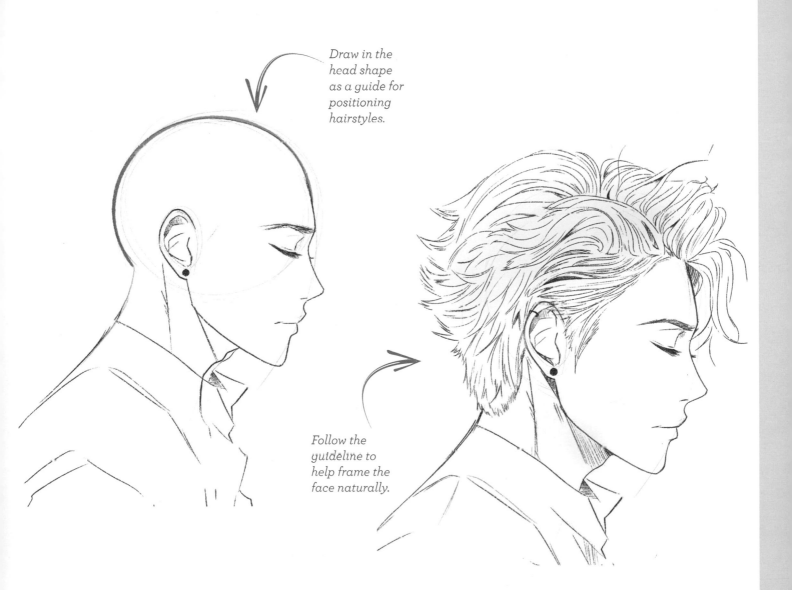

Draw in the head shape as a guide for positioning hairstyles.

Follow the guideline to help frame the face naturally.

MANGA HAIRSTYLES: LONG

Although there are various male characters with long hair, it is an attribute that many artists use to emphasize feminine traits. Girls' hairstyles range from simple flowing locks to styles that incorporate plaits, bows, clips and other accessories. Similar principles apply to drawing short hair (see pages 40–41), but long hair takes more time and requires a rhythm and consistent approach to maintain shape and flow along the length. Fringes, plait and partings all require a little more detail to render accurately, but the results will be stunning.

Drawing a full fringe

First, work out where the fringe is going to start; a long fringe requires hair from the whole head, not just the hairline. At the sides will be a transition to longer hair; mark this with longer strands to differentiate between the two.

To show the hair tucked behind the ear, add lines that indicate a split in the hair at the back of the ear, with a strand or two coming forwards and then others going backwards.

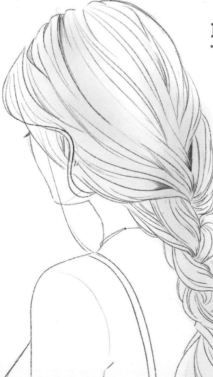

Drawing a plait

To understand how a plait is drawn, you need to have an idea of how to achieve this hairstyle in real life; look at photographs, or practise on yourself or someone with long hair.

Note the shape of the head and where the nape of the neck begins, which is where the hair will form the bulk of the plait. Next, add a line that indicates the middle of the plait and follows the angle of the plaited hair. This helps the symmetry of the style, but to keep things natural, don't make it too symmetrical!

Make sure that you don't put too much pressure in the pencil strokes and try to be as smooth as possible with the strokes that have slight curvature in them.

MANGA ART SECRET

Giving your character long, flowing tresses of hair is an instant way to add some manga style. Draw sweeping lines that have a regular rhythm along their length – the trick is to avoid making all the lines identical. Start by practising long lines with straight hair, then give them a gentle undulation as you become more confident. Finish with a big bow!

To help you to understand the way that the hair relates to the head, draw a light outline of the head and face that can be erased later. Long hair especially needs to have a starting point on the head that follows the head shape and angle of the pose.

FEMALE HAIRSTYLES

Your hairstyle often says a lot about your personality, and the same is true for manga characters. Female hairstyles have many variations and you can experiment with how different styles affect the overall look of your character. Try drawing the same head with short, long, plaited, wavy and straight hair, with a fringe or without, and see what effect it has. You can also simplify the look to the point where there are no strands, just outlines of sections.

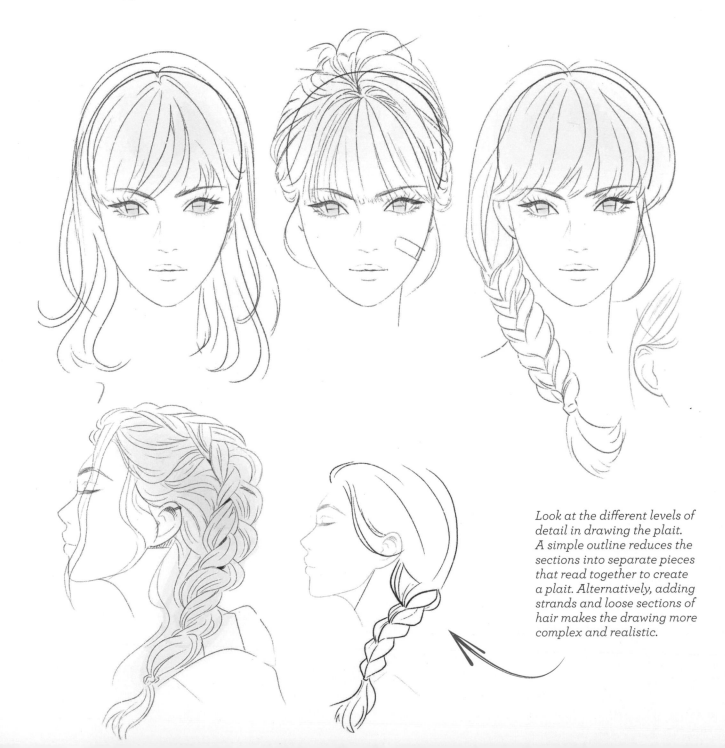

Look at the different levels of detail in drawing the plait. A simple outline reduces the sections into separate pieces that read together to create a plait. Alternatively, adding strands and loose sections of hair makes the drawing more complex and realistic.

Adding natural movement

Giving a sense of movement to long hair is essential and adding the suggestion of locks blowing in the wind creates a romantic atmosphere in any drawing. Capturing this sense of movement requires careful observation of the separated strands and the ends of the hair. Avoid making all the strands the same width or blowing in the same direction: vary the thickness and add an inner and outer curve along the full length of a long tress, making the inner line a heavier weight and darker shade.

Always pay attention to the ends of the hair. Try to add variety to the shape of the ends, drawing them with the appropriate thickness in relation to the hair volume.

FEMALE HAIRSTYLES: INSPIRATIONAL IDEAS

There are so many possible hairstyles for female hair! Not only can you choose from short, through mid-length to long, but you also have many options for upstyles in buns, ponytails, pigtails and plaits, let alone the huge choice of hair accessories. Experiment with all the options to add touches of personality. If your character appears multiple times or from different viewpoints, then ensure you maintain continuity in the placement of hair and any fashion accessories.

Hair direction

Pay attention to the direction the hair falls in and start your lines at the crown of the head, drawing downwards towards the tips of the hair.

As you learn and grow in confidence, experiment with more complex hairstyles; this is a great way of getting creative in your drawing.

Accessorizing

Use hairstyles as a way to start experimenting with adding hair accessories and touches of personality. For example, the hairstyle on the far right can be used to understand the flow of hair in hairstyles that are tied in a similar way, such as a high ponytail or bunches.

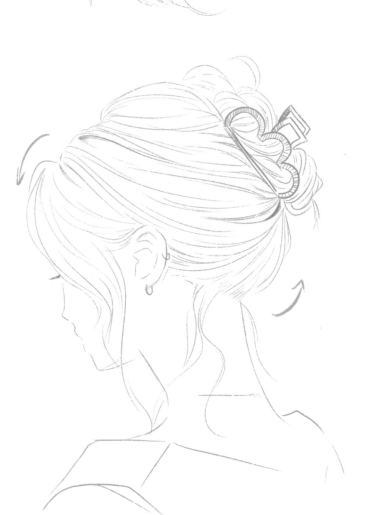

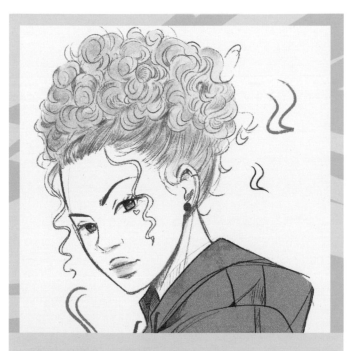

MANGA ART SECRET

To practise drawing tight curls made of curved lines, keep drawing circles. Your hand muscles will adapt to the movement, loosening up to help you achieve naturally curved lines.

This long style follows the head shape with a separate ponytail. See page 49 for more on drawing ends.

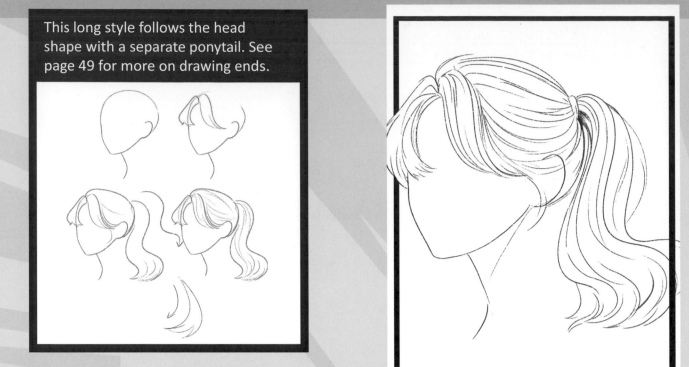

EXERCISE ROUND-UP

Each of these exercises will guide you through the simple steps of creating a hairstyle, long or short, male or female. At each stage start with a simple head shape, noting the jaw line and ear placement, which may affect how the hair falls. You can adapt these principles to any style, whether simple strands or with more complex layers and accessories.

Build up a full head of hair in stages, starting with general direction and adding volume. See pages 40–41 for tips on drawing short hairstyles.

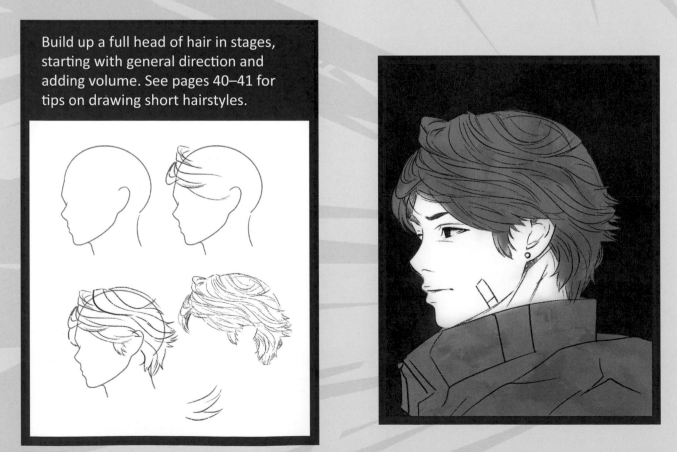

To draw a side parting, follow the general principles, using the head shape with a dividing line as a guide. Add flicks at the ends of the strands.

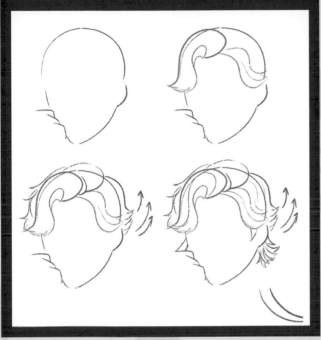

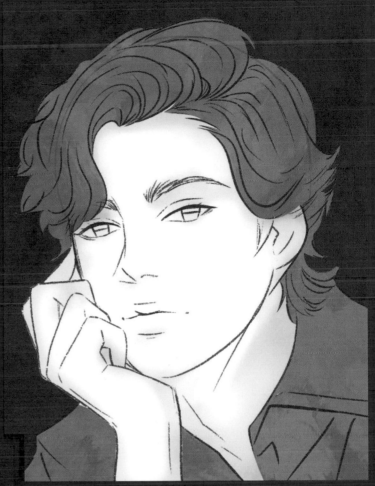

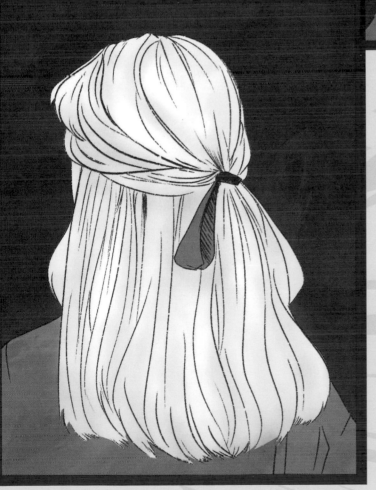

A long hairstyle from the back can be simplified into sections. See pages 50–51 for how to add volume and gentle waves, using a bow or clip to change the style.

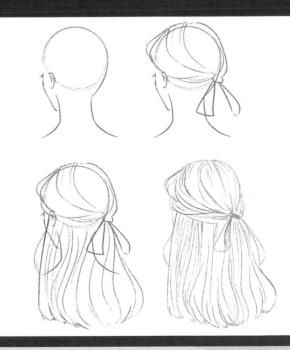

DIANA MAJED (@DIANA1992D)

I am Diana, the twin sister of Dalia, the author of this book. Although we both love drawing, Dalia and I have quite different styles. Since I was a child, I have enjoyed watching Disney movies and began by drawing the characters I admired. I continued to draw, getting a lot of pleasure from practising and developing a passion for my work. Now I draw every day, always looking for ways to improve. It is never too late to start drawing – it just takes passion, patience and time!

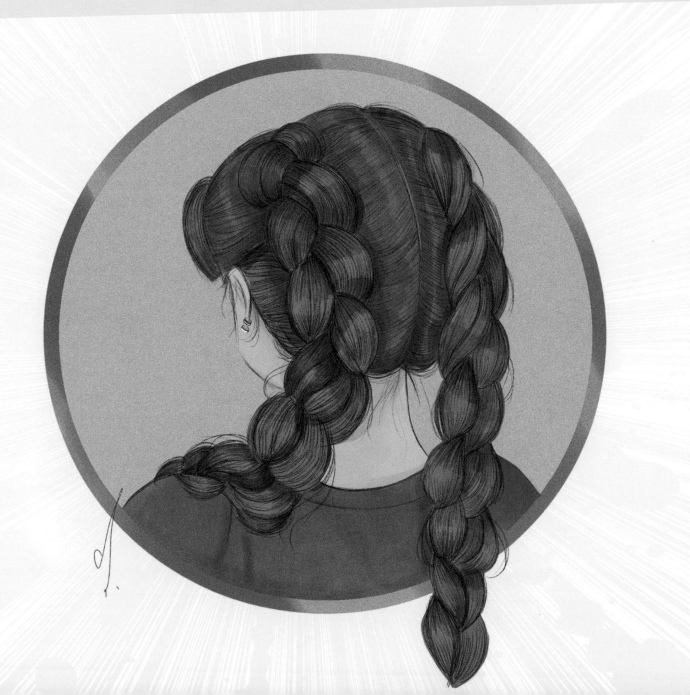

MANGA ART SECRET

I prefer to start my drawings with pencils and paper, as I love the hand-drawn effect achieved by shading with graphite pencils. I sometimes use watercolours, as the washed-out shades of colour that water-based paints create really go with my style.

Chapter Three
DRAWING BODIES

Drawing the body can seem challenging at first. It forms the base for your character's pose, is the foundation for clothing, reflects gender and, above all, there are multiple elements and endless variations. However, in this chapter you will see how, by reducing the body into simple shapes, you can face the challenge and bring everything together so that you can draw any body shape you want. The key is to understand proportions and how these are similar even if the body shape is different. Simplifying each body part to a general shape makes them much easier to draw. Once you've mastered these components, you will soon be able to combine them into an expressive pose. To help, use selfies, photographs or live models, or copy a favourite manga character to practise, and then create one of your own.

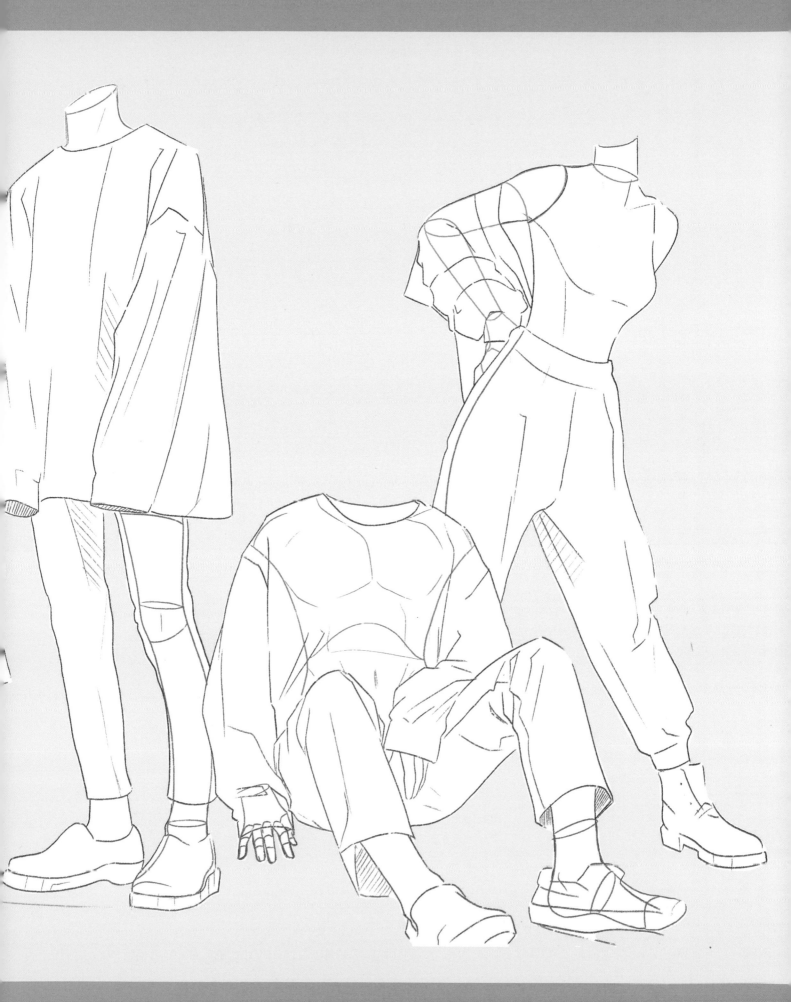

UNDERSTANDING BODIES

Before you begin drawing the body, take some time to observe how the body's internal structure influences the shapes and poses that we see on the outside. The skeleton is the framework that affects the height and build of a person. As an artist, it is not necessary to know all 206 bones and their shapes, but look where they are visible under the skin, creating solid shapes, lines or angles. Another guide is to divide the body into sections based on proportions. Although every body is different, these general rules will help you to draw a realistic character.

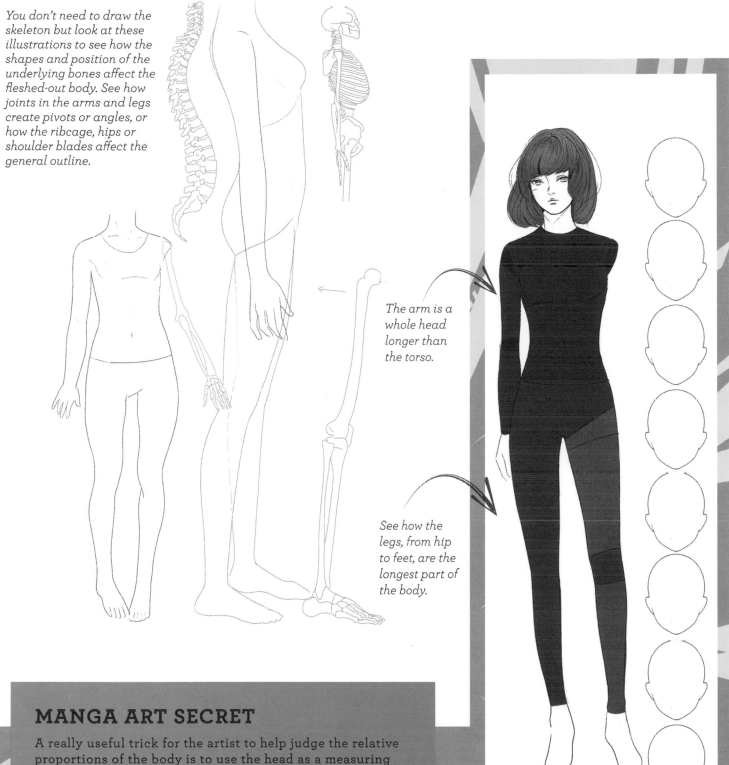

You don't need to draw the skeleton but look at these illustrations to see how the shapes and position of the underlying bones affect the fleshed-out body. See how joints in the arms and legs create pivots or angles, or how the ribcage, hips or shoulder blades affect the general outline.

The arm is a whole head longer than the torso.

See how the legs, from hip to feet, are the longest part of the body.

MANGA ART SECRET

A really useful trick for the artist to help judge the relative proportions of the body is to use the head as a measuring guide. The height of an average adult is about 7.5 heads and you can use this ratio for any body, male or female. Keep checking the head unit and use it to judge the scale of other body parts; for example, the length of an arm is about 3 heads, compared to the torso, which is 2 heads long. Once you understand the relative proportions of the body parts, your drawing will look accurate and your character realistic.

DRAWING MALE ARMS

Now that you can draw the body as a whole, it's time to look at the individual components that give your character a sense of movement and expression, starting with the arms. With a range of motion and gestures, the arms may seem complicated but my approach is to simplify the overall form into geometric sections, seeing them as abstract shapes. Starting with these shapes you can then take into account the muscles and bones that add structure, 'fleshing out' the basic arm to suit your character's body type and build.

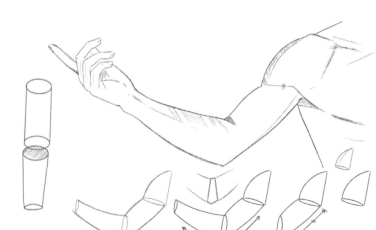

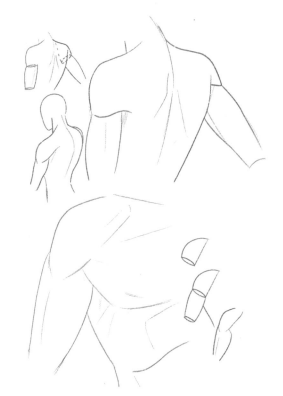

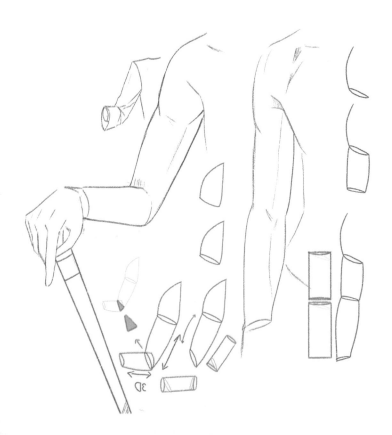

Simple ways of drawing arms

Looking at the proportions of the arms: they divide into two equal halves, from the shoulder to the elbow, and elbow to wrist. With the arm held straight at the side of the body it is easy to simplify these two halves into two cylinders. The next step is to look at where the arm joins the shoulder, and divide the top part of the arm into two segments that reflect this transition. Use abstract shapes to help you visualize the three different parts, thinking about the muscles that give a curve to each segment, and using the bone structure to give direction. Try this with different poses, noting how perspective will shorten the forearm when seen from different angles.

How you join the three segments of the arm together varies with different poses, and the junctions between the shoulder and elbow are key points where these shapes change. Think about the bones and how they correspond to the muscles, which give form. Draw your geometric shape lightly as a guide, then add smooth pencil strokes to draw curves and shading to make the arm more realistic.

The curve of the shoulder follows the bone beneath.

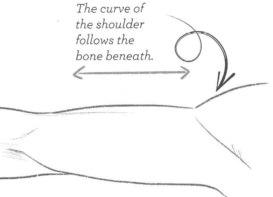

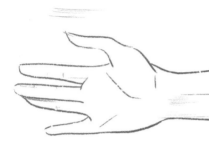

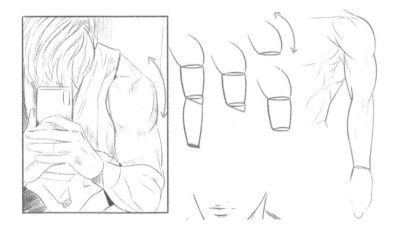

Drawing muscles

All these examples show male arms, which tend to be more muscular than female forms. It is relatively simple to give your manga character an exaggerated build; just draw the biceps and triceps with a greater curve to indicate larger muscle. Add shading to give more substance to the muscles, using lines and strokes to mimic the tension of the skin. Even if your character is clothed, these shapes will still be visible in the folds of the overlying fabric.

MANGA ART SECRET

The size of muscles needs to be in proportion to the size of the body. A more muscular body will look more natural with muscular arms.

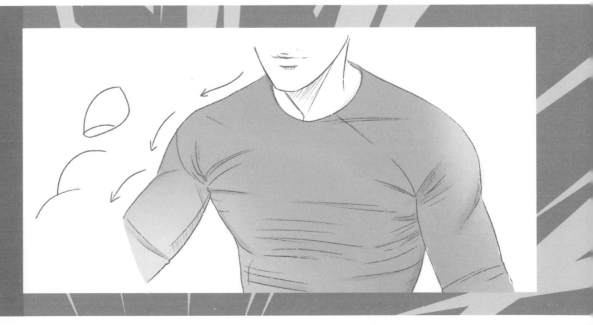

DRAWING FEMALE ARMS

Compared to the male physique, the female build is slighter, as women have smaller muscle mass and less dense bones than men. When drawing arms, this simply means that you follow the same principles as described on pages 60–61 but with a sleeker profile. With lighter muscle mass, the bones may be more prominent and angles accentuated at the joints on the elbow and wrist.

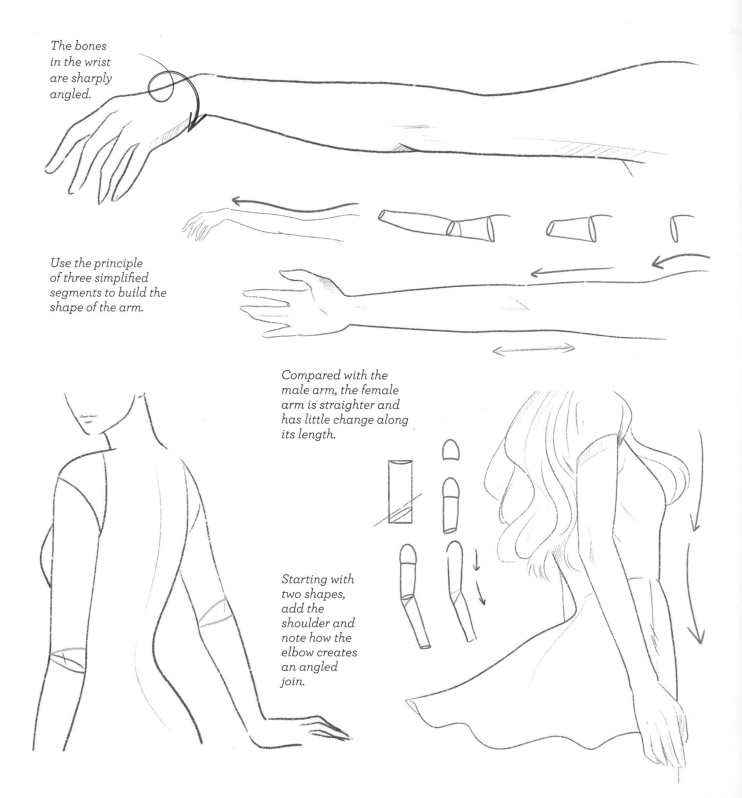

The bones in the wrist are sharply angled.

Use the principle of three simplified segments to build the shape of the arm.

Compared with the male arm, the female arm is straighter and has little change along its length.

Starting with two shapes, add the shoulder and note how the elbow creates an angled join.

Expressive arms

Because of their range of motion, arms are key to many poses and actions, with a body language that can be universally understood. Use the placement of the arms to express emotion or add to the personality of your character. Try lots of different poses, observing how the muscles change to create movement and how each part of the body relates to the other to bring the pose together.

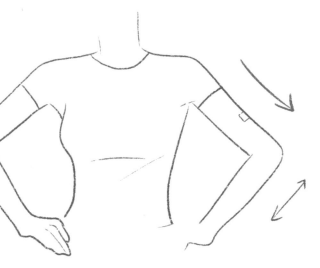

With hands on hips, the strong angles of this pose are similar whether they viewed from the back or front, and convey a defiant and empowered mood.

With arms kept close to the body, a protective and even secretive pose is implied.

MANGA ART SECRET

Practise different poses, taking inspiration from anime characters. Bold poses convey body language clearly, from anger in crossed arms to the welcome of an open embrace.

DRAWING HANDS

Because of their many bones and joints, hands have a huge range of motion that creates an equally huge range of positions and poses. The complex structure beneath the skin is mirrored closely in what is visible on the surface, with knuckles and joints creating ridges and lines at points of tension. A realistic rendition of the hands is a complicated undertaking but in manga style you can simplify your drawing, maintaining the correct proportions, but just hinting at the complex structure. To help get you started, I have devised ways to divide the hand into component parts based on simple shapes – a rectangle for the palm and cylinders for the fingers. Taken in stages, you will soon master the basic elements and can then move on to more complicated poses and gestures.

MANGA ART SECRET

Your own hands are always available to stand in as models. Observe closely how gentle bends or subtle changes in spacing add up to an expressive pose and then simplify the gesture to basic shapes, checking proportions in relation to the whole figure.

Drawing the basic shape

The best position to start with is an open hand with extended fingers. This will familiarize you with the general proportions of the different components and how they relate to each other. The bone structure is important to understand, so that the fingers follow the overall shape of the bones, decreasing in width towards the fingertips, with curves at the base of the thumb to the wrist.

Each finger divides into three sections with divisions at the two joints. But note that the thumb only has one joint.

1 Start with the palm, reducing it to a simplified rectangle.

2 From the palm, draw light lines that indicate the beginning, middle and end of each finger.

3 Start to add the separate segments to each finger, using a simple cylinder shape based around the guides from Step 2.

4 As you draw the fingers, add gentle curves to the tips and joints to give them a realistic shape, narrowing the width towards the fingertips.

Looking at the hand in the same position, only with the palm facing you, the same principles apply but you need to add a suggestion of fine lines across the palm and creases on the fingers.

EXPLORING HANDS

Now that you are familiar with the proportions of the hand in resting and relaxed poses, it's time to move on to mastering how the shape changes with different gestures and movements, and when holding objects. Parts of the fingers may be hidden, folded or tucked away, but take a moment to look at the mechanics of these movements – the joints and muscles beneath the surface – and then break each element down into its component parts. Use your own hand as a reference and keep practising; you can leave out fine details and just concentrate on the pose and what it says about your manga character.

With the palm facing out and hand clenched, map out the shapes of the individual jointed fingers, sketching in the segments even if they won't be visible in the final drawing.

Closed fists
· · · · · · · · · · · · · · · ·

With clenched fingers, a closed fist takes on a very different form to the open hand. Start with the overall shape as a simple rectangle and add dividing lines between the closed fingers, with right angles where the fingers bend. Add the thumb on the outer edge and any creases to give a realistic finish.

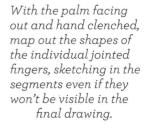

Taken in stages, a closed fist is a relatively simple exercise with a dynamic result.

Seen face on, a closed fist is full of tension. Start with a simplified outline and then add lines to mark the fingers, checking proportions.

We use our hands to hold all sorts of different things, and this can present more of a challenge than drawing the hand on its own; parts of the hand can be hidden and it's important to capture the pose so that the grip looks convincing. Here, most of the hand is visible with the object grasped inside. Start with the overall shape of the hand and add a rough sketch of the object in order to gauge its size. Draw the fingers as usual, checking that the grip matches the width of the object.

Starting from a basic shape that follows the direction of the pose will keep the angles consistent as you add more details.

MANGA ART SECRET

Although hands are expressive, it doesn't mean that you have to use a complicated pose to convey an emotion or hint at your character's personality. Look at how hands combine with other body language to tell part of the story and try to match a pose to your manga character. The gestures on the following pages are a starting point, but keep sketching and you'll soon have a personalized selection to draw on.

HAND GESTURES

Hand gestures are a part of the way we communicate. We use our hands to explain and direct as we speak, to convey messages and emotions, and, generally, they complete a character's personality. Keep practising and drawing different combinations of gestures, adding objects for the hands to hold as you gain confidence. These extra components, such as a pen or cigarette, simply need to connect to the hands in a realistic way. Look closely at hands in real life, keep shapes simple and you will soon get the hang of it.

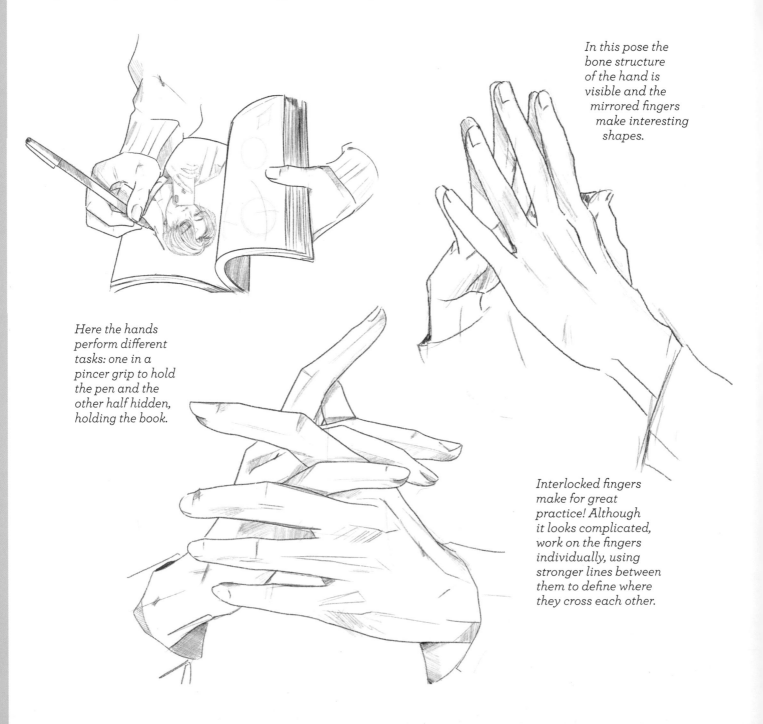

In this pose the bone structure of the hand is visible and the mirrored fingers make interesting shapes.

Here the hands perform different tasks: one in a pincer grip to hold the pen and the other half hidden, holding the book.

Interlocked fingers make for great practice! Although it looks complicated, work on the fingers individually, using stronger lines between them to define where they cross each other.

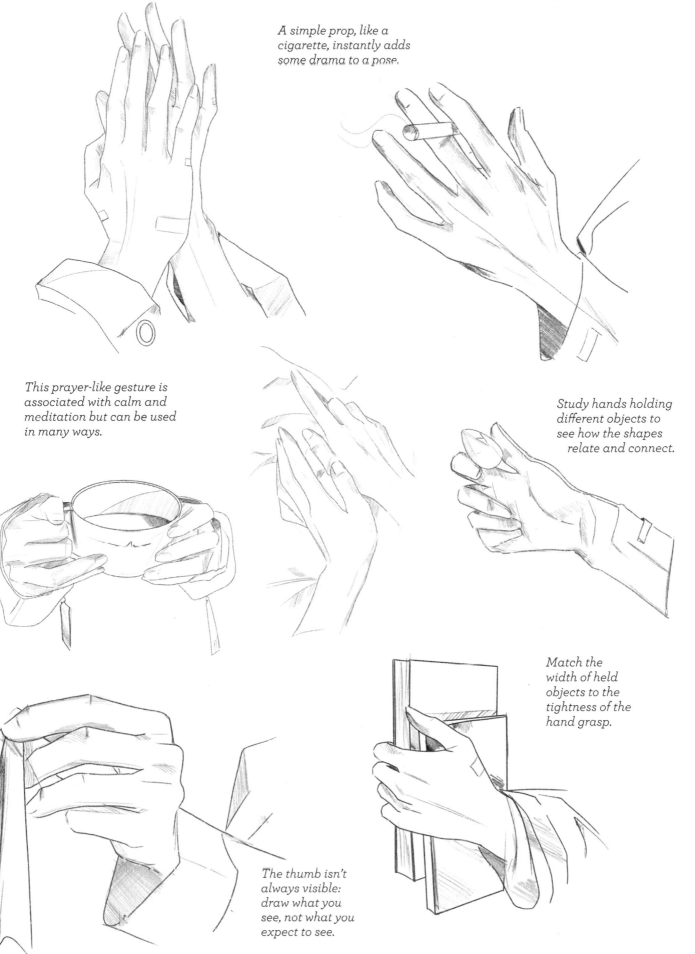

A simple prop, like a cigarette, instantly adds some drama to a pose.

This prayer-like gesture is associated with calm and meditation but can be used in many ways.

Study hands holding different objects to see how the shapes relate and connect.

Match the width of held objects to the tightness of the hand grasp.

The thumb isn't always visible: draw what you see, not what you expect to see.

DRAWING TORSOS

To distinguish between male and female characters you need to make a few changes to the basic body shape. The torso is the key to this natural distinction – male figures have more angular outlines compared to softer female curves. Even if your character is clothed, it will look more convincing if you have the correct outline beneath.

Drawing a male torso

As with other body features, the trick to drawing any torso is to start with a simplified geometric outline and use light guidelines to plot the muscles of the chest and abdomen.

1 For a male torso seen from the front, start with a trapezoid shape that is wider at the top and narrows at its base.

2 Now add some guidelines. I usually just split the body into two segments that are roughly symmetrical.

A wider torso and defined abs give this body a toned and muscular look.

3 Check the overall proportions are correct and add curves where the waist narrows.

4 Add more detail, using lines to indicate muscles. The more lines, the more muscular the build.

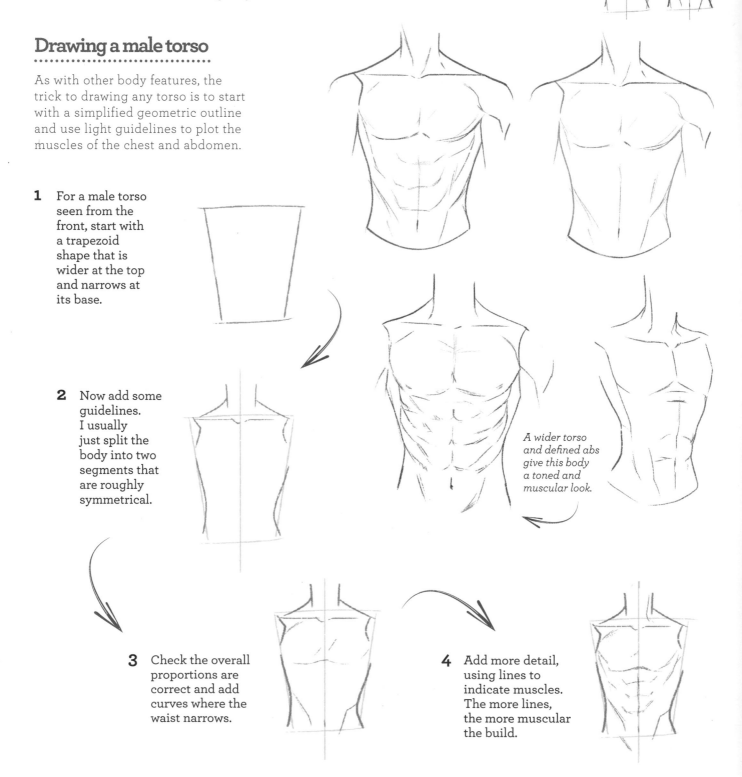

Female torsos

When drawing the female body from the front, follow the same basic techniques as for the male body, but rounding off any angles to capture the natural curves. Start with a trapezoid shape and add guides to divide it roughly in half. Mark the base of the bust too, about a third of the way down. The waist is generally more accentuated than in the male body, with a smooth transition to the hips.

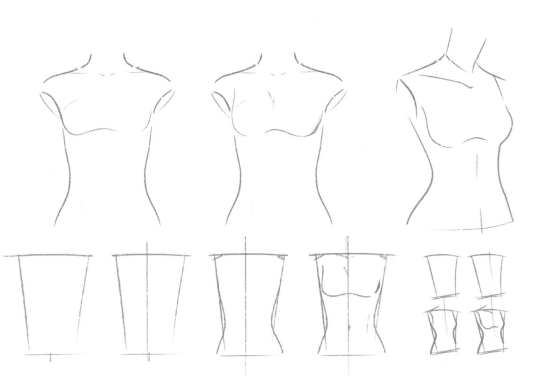

Torsos from side view

When drawing a side view, you will need to suggest the curvature of the spine, in both male and female torsos, to give your manga figure a natural stance. It helps to think about the underlying skeletal structure of the ribcage, spine and pelvis, and how these bones form the foundation of the body's profile. The ribcage gives width, the spine a natural curve, and the pelvis the shape of hips and rear. To gauge the curve of the spine, draw an angle in the basic box shape and divide the box in half to balance the features.

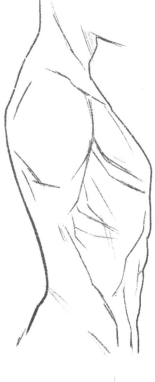

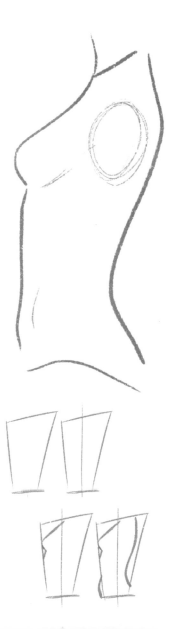

DRAWING LEGS

Now that you've mastered the upper body, you're ready to apply what you've learned to the lower part – the legs and feet. Taking up twice the length of the torso, it's important to get the initial proportions correct. Remind yourself of how the whole body can be divided (see pages 58–59), and then look at the legs in detail to break them down into sections. Different views will require slightly different shapes to match the muscles and bones beneath, but keep practising, using photographs as reference for lifelike poses.

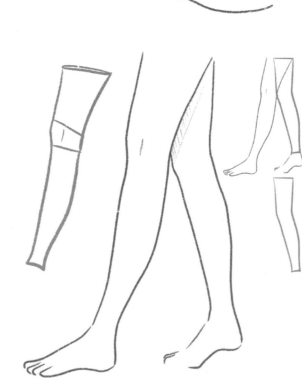

Keeping the proportions correct, bent legs divide into roughly equal parts, with a smooth curve where the knee bends.

An undulating line is all you need to draw the outer leg shape from the rear.

In a walking pose, each leg will be in a different position. Look carefully at the forward angle of the front leg, with the knee section facing up. The back leg is relatively straight. Draw the whole back leg to ensure the proportions are correct, then erase the top part where the legs overlap.

Leg proportions

The basic shape of the leg divides into two equal sections, above and below the knee. Start by simplifying the overall shape into these segments: it may help to draw a rectangle at first and then add the gentle curves. Along the leg there are a number of natural curves – the hip, thigh, knee and calf – and you can further divide the leg into these sections. Female figures tend to have smoother curves than males and slender proportions, but the basic principles remain the same.

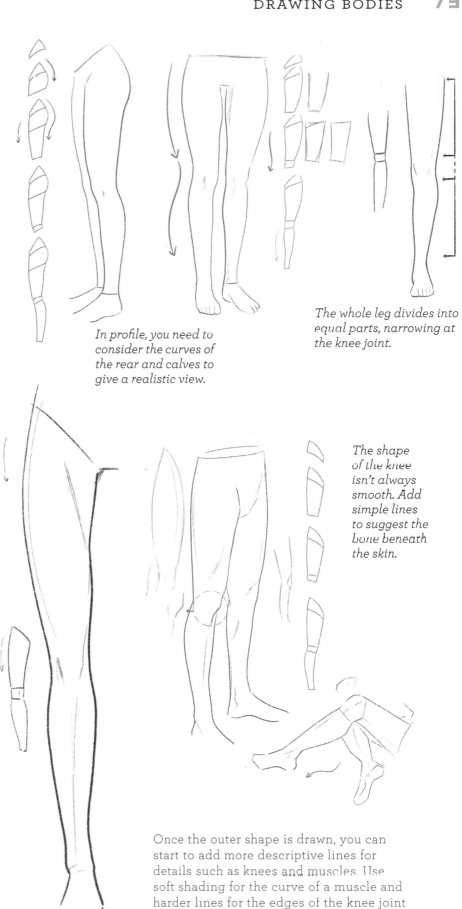

In profile, you need to consider the curves of the rear and calves to give a realistic view.

The whole leg divides into equal parts, narrowing at the knee joint.

The shape of the knee isn't always smooth. Add simple lines to suggest the bone beneath the skin.

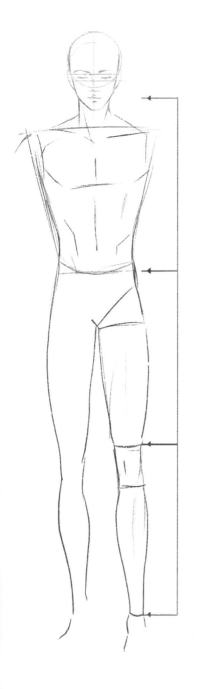

Once the outer shape is drawn, you can start to add more descriptive lines for details such as knees and muscles. Use soft shading for the curve of a muscle and harder lines for the edges of the knee joint or ankle bones. Even on a clothed character, these details may still be visible.

DRAWING FEET

Although small in comparison to the rest of the body, the feet are an important feature to get right. They need to support the figure and look stable, connecting the body to the ground in a realistic way. Start with some simple views and then keep practising, drawing the feet from many different angles.

The bottom of the foot is a good place to start. Draw a basic outline and then add the curves of the footprint. Seen from the top, the shape becomes squarer, widening towards the toes.

Simple feet

Start by looking at the foot from the top, bottom and side profile. Although the shape differs in each view, the basic proportions are similar, with the main length of the foot providing a regular shape and the toes making a relatively small but detailed section at the end.

The bone structure of the foot is visible on the surface in the heel, ankle and toes.

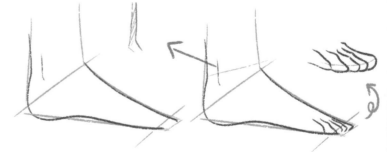

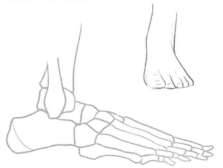

MANGA ART SECRET

For an accurate and professional rendition of feet it will help to study them in detail. Look closely at the different curves and angles where the feet and toes flex to aid movement or maintain balance. Keep the basic proportions in mind and divide the foot into sections, adding details such as the toes and the undulations on the sole of the foot once the shape and angles have been established. Although other features are often simplified in manga, getting the feet correct is important for giving your character the foundation for a strong pose.

CHARACTER POSES

All the different elements of the body come together in a pose. This is where you can convey emotion, personality, style, humour, sadness or love. On the following pages you'll discover how to simplify the overall pose, using the different body parts to render the figure accurately, and how to think through the process, from concept to the finished, clothed character. To give variety to your poses you will need to change the viewpoint and angles, and observe perspective. This may be challenging at first, but keep drawing and it will get easier!

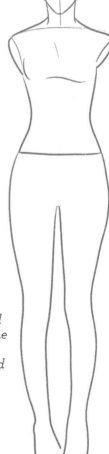

A conceptual drawing of the front view is balanced and symmetrical.

MANGA ART SECRET

For a realistic pose, draw shoulders angled slightly downwards and curved, rather than with sharp, rectangular edges.

Simple standing poses

A standing pose is a good place to start as the angles and shapes of the figure are fairly easy to draw. Even though the figure in most drawings will eventually be clothed, I find that making a conceptual drawing first helps me to achieve the correct balance and proportions. This means sketching the pose as a simplified shape, starting with the head, then the torso, followed by the legs and, finally, the arms. Bear in mind that you may need to alter the tilt of the head to adjust to the angle of the pose.

Take your time to get your conceptual underdrawing correct before you build on it to add features such as the face and hair, and then the clothes and shoes.

FEMALE POSES

Female manga characters adopt quite quirky poses, where the slightly awkward positions can convey a lot about their personalities. Approach these more complex positions by simplifying and drawing each body part individually, connecting them together to build the whole pose.

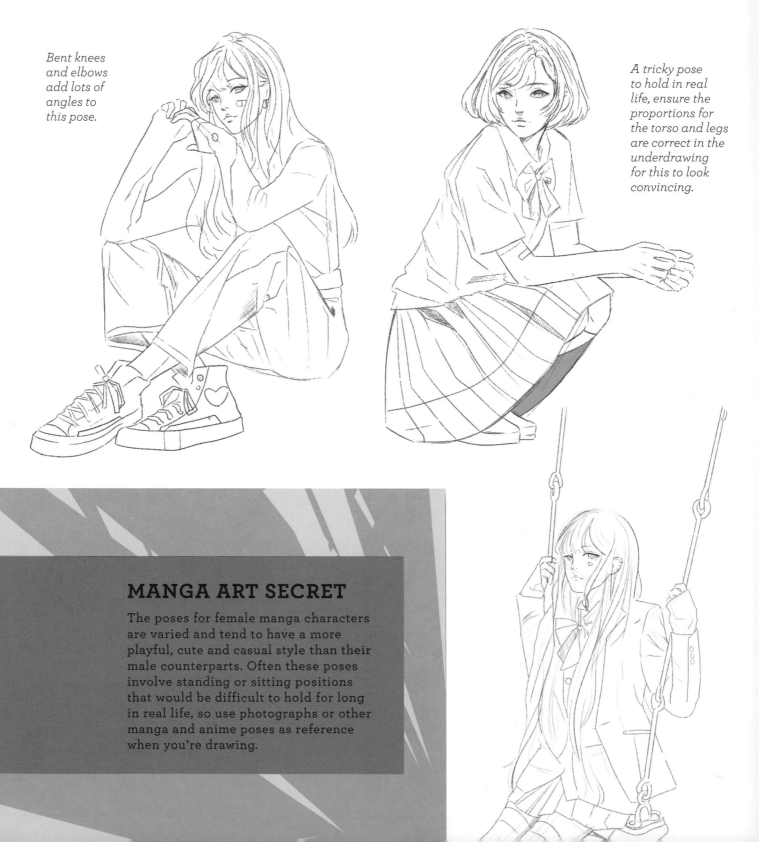

Bent knees and elbows add lots of angles to this pose.

A tricky pose to hold in real life, ensure the proportions for the torso and legs are correct in the underdrawing for this to look convincing.

MANGA ART SECRET

The poses for female manga characters are varied and tend to have a more playful, cute and casual style than their male counterparts. Often these poses involve standing or sitting positions that would be difficult to hold for long in real life, so use photographs or other manga and anime poses as reference when you're drawing.

As with simpler poses, start with a conceptual underdrawing that maps out each of the body parts. Draw lightly so that the guidelines can be erased later without a trace. In more complex poses, you may start the pose with a different body part. For this drawing, I started with the torso rather than the head as this gave clues to the angles of the legs and arms. The top part of the legs appears shorter in this seated pose because of the effect of perspective, known as foreshortening.

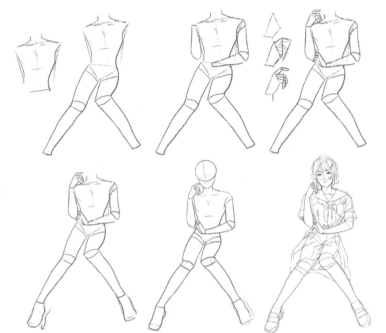

In this side profile, there are very few hard angles, just gentle curves that connect the body and legs. The angle of the turned head gives the pose its charm.

Introducing objects for your character to hold adds another layer of complexity. Start your drawing at this point and build the pose around it.

MALE POSES

Compared to female characters, the emphasis in male manga poses tends to be on showing strength, masculinity and power. They are less cute, and more rigid and mysterious. How you compile and draw the pose, however, follows the same principles: starting with a sketch or conceptual underdrawing where each of the body parts is simplified and lightly drawn to ensure that the proportions and anatomy are correct.

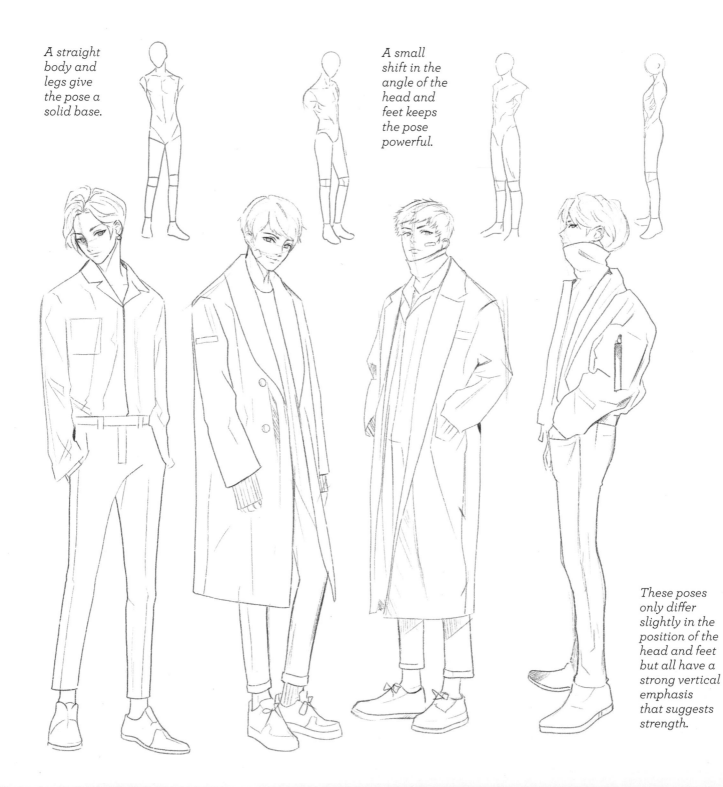

A straight body and legs give the pose a solid base.

A small shift in the angle of the head and feet keeps the pose powerful.

These poses only differ slightly in the position of the head and feet but all have a strong vertical emphasis that suggests strength.

1 Draw guides. Start with guidelines that follow the main parts of the body – arms, legs, torso – and observe the angles that reflect the direction of movement.

2 Add outlines. Use the guides to add outlines of body parts, checking proportions and correcting where necessary so that you don't have to readjust at a later stage.

3 Build details. Add more details to the hands, feet and face until you are at a point where you can add hair and clothing on top.

4 Check angles. The position of the feet and legs gives the sense of movement, so check that their placement looks realistic and the figure appears balanced.

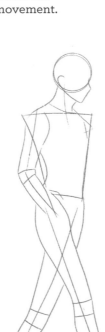

Drawing a walking pose

When starting to draw, some poses are more challenging than others. A figure in motion can seem hard to pin down and it will take close observation to render it correctly. Don't rely on your memory, or what you think should happen – look carefully at how people move in the world around you and take photographs or use other drawings or stills as reference.

SITTING POSES

In contrast to a standing pose, seated figures involve more complex shapes where joints bend, ankles cross and feet rest. Points of contact with a seat, or the ground, need to be consistent to keep the figure anchored and your finished drawing looking realistic.

How the body bends when sitting creates smooth and angular shapes. Look at the profile of the back to achieve a realistic drawing.

Right angles between the torso and legs, and at the knee, suggest a a seated pose.

For a cross-legged pose, start with the legs. To make the pose look believable, position the ankles centred in line with the crotch and the legs relatively symmetrical on either side. Add the torso, angling it slightly here to allow for the slight tilt of the head and the raised arm. Although the ankles aren't visible in the finished drawing, the pose is accurate.

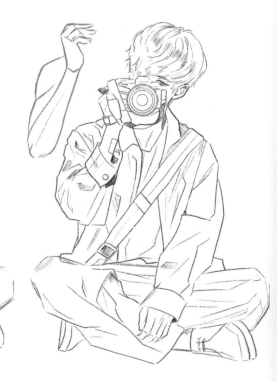

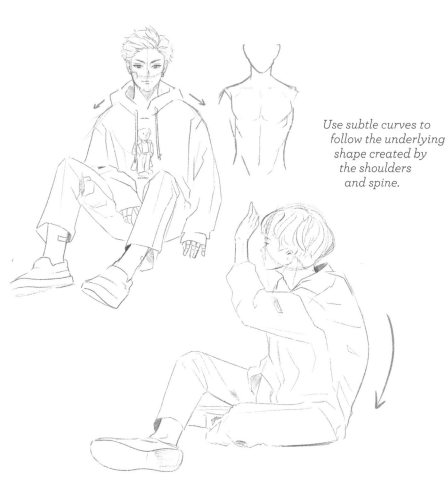

Use subtle curves to follow the underlying shape created by the shoulders and spine.

Adjust the length of the leg to add depth when it is extended towards you.

MANGA ART SECRET

Taking a photograph of the pose that you are trying to achieve, either a selfie or of a friend, will really help you to understand how the body works together to maintain the position. Analyze the different body components, check proportions and study details.

A simple hand comes together really quickly. See pages 64–65 for more.

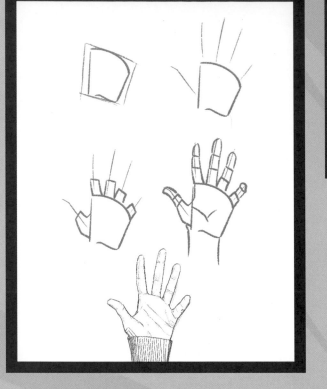

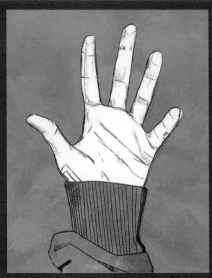

Draw the feet in profile to understand the basic proportions and then try the different views on pages 74–75, to gain more confidence.

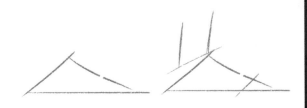

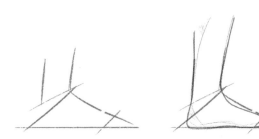

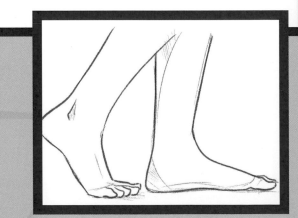

EXERCISE ROUND-UP

Familiarizing yourself with the body and its various component parts will give you confidence to draw an accurate and realistic pose. Figure drawing takes practice, lots of it, so use these exercises to revise some of the basic approaches to each body part. Remember to simplify the shapes to begin with a light underdrawing, and then build the detail on top. Look back through the chapter to refresh your memory and keep in mind the proportions in each part of the body so that when you put them together they will look convincing – and give your manga character a pose that completes their personality!

Draw the torso as a simple, geometric shape. For men, match wide shoulders with defined muscles (see page 70).

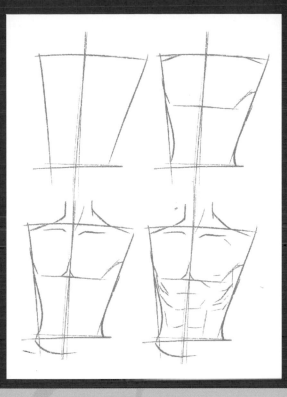

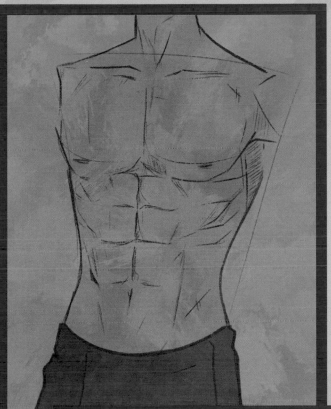

Follow this exercise to draw an arm. You can adapt these basic principles for a male or female character; see pages 60–63 for more ideas.

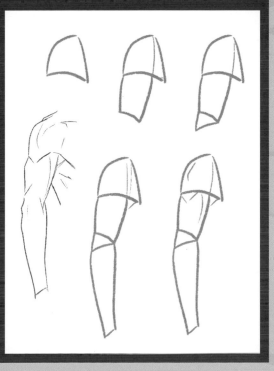

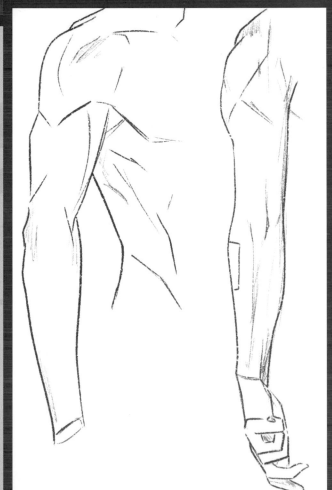

EDINA T (@TASTYSAKURA)

My name is Edina, and I was born and raised in Hungary. Since childhood, I've been interested in anime, manga and Japanese culture. Inspired by various television shows, my dream was always to be able to create something similar – first on paper, then digitally on a computer. The biggest compliment I could ever receive about my art is: 'This looks just like a scene out of an anime!' That's exactly what I'd like people to think when they look at my illustrations. I often get asked if I have any kind of secret or trick to my work, but all I can say is that 'less is more': try not to overdecorate or overdo an artwork.

MANGA ART SECRET

When I choose colours for my drawings, I always aim for them to be in 'harmony' and for my illustrations to be pleasant to look at. For this reason, I'm not a fan of intense colours, so I usually stick to a palette of pastels or muted, earthy colours. People tend to comment that this gives everything a soft and dreamy feeling.

Chapter Four
DRAWING CLOTHES

Dressing your manga character gives you another opportunity to shape their style and personality. Manga clothes are inspired by outfits in real life, but you can vary the look in many ways based on factors such as era, age or gender, or combine looks to create quirky and original styles that are unique to your character.

In the following pages we'll look at the basic clothes categories and how to simplify and draw them in different poses. To help, study clothes in real life, using photographs or illustrations to understand how fabrics fold and crease. Use your knowledge from the previous chapter on how to draw the body as a foundation for adding clothing and shoes on top, and then your character will look effortlessly stylish and well dressed!

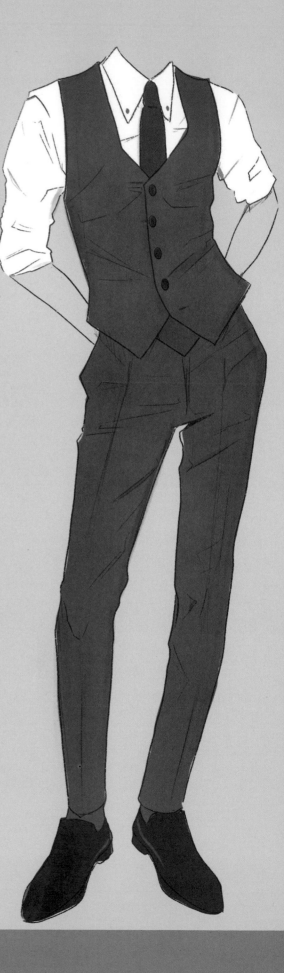

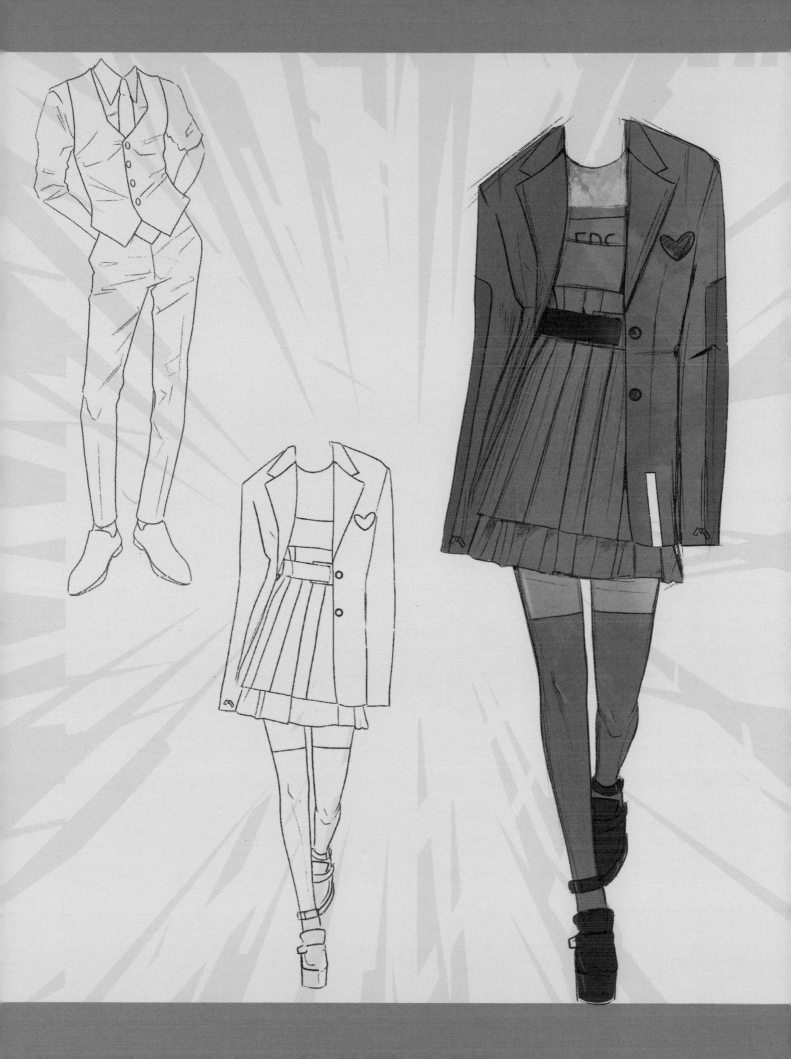

DRAWING CLOTHES

Without a body inside, clothes won't look natural or hang correctly. To start dressing your character you need to understand how the body affects the look of the fabric, and how these folds, gathers and creases make your drawing appear more believable and communicate a pose more accurately. At this stage, simply study the effects of the body and movement on clothes, using yourself or a friend as a model, and take reference photographs to help you. Start with the outline of the body drawn lightly beneath, keeping things simple and just noting the main lines of tension through the fabric.

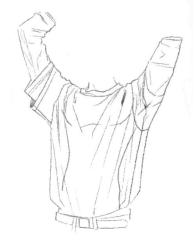

To reflect how clothes appear in real life, a drawing of a character that is stretching, sitting or even just moving slightly needs to show the resulting folds in the fabric. For example, look at the illustration here where the character is raising his hands: the folds are vertical and match the direction of movement and the tension caused as the fabric stretches from where it is tucked into the trousers.

To help understand how a pose affects the way you draw clothes, look at the same outfit in a standing and sitting pose. When standing, the skirt maintains its original shape following the hips. When seated, the hem gathers over the knees with creases in the centre.

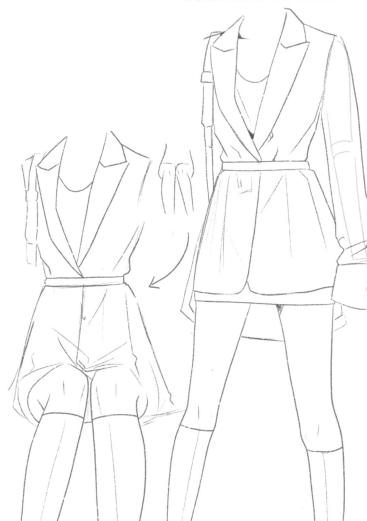

MANGA ART SECRET

Drawing the shape of the legs first will really help when drawing trousers. Here you can see exactly where the right knee is resting on the left, and how this affects the way the fabric folds and gathers along the trouser legs.

FOLDS AND GATHERS

When drawing clothes, the type of fabric they are made from will play a huge role in how the folds, creases and gathers will look. Some fabrics fold and crease more than others – compare the fluid look of silk to the structure of a wool suit – and these characteristics can be reflected in your drawing style. Aim to give a dynamic quality to folds or gathers and, to make them look natural, avoid repeating shapes and sizes.

Draw the underlying shapes of the shoulder and arm muscles to help guide your placement of the fabric creases.

In this illustration showing a bent and raised arm, the sharp angles created on the inner edge of the elbow bend, as well as the muscles of the shoulder and biceps, create creases in the sleeve. Start with the basic arm shape, then add the main areas of fabric tension, building up the density of folds where the arm flexes.

The darker the shading, the deeper the fold in the fabric.

Skirts are great fun to draw, indicating movement and playfulness. The effect of a gentle breeze can easily be shown and is a common theme in manga drawings.

Gathers in a pleated skirt move in different directions to show movement.

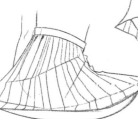

Start with a simple shape, then add ripples on the hem for a hint of motion or a twirl.

MANGA ART SECRET

Crisp and defined folds show the most clearly in formal shirts, commonly worn by male characters. The light, easily creased fabric is simple to render with precise lines and can be a good way to add to the personality of your character. A particularly creased shirt might indicate the character is tired, or sad.

DRAWING TOPS

Much like real life, there are many styles of tops that you can use for your female characters. To give an outfit a manga look, it is common to layer clothes and this gives you the chance to play with outfit combinations that shape a character's personality. Mixing and matching different fabrics and styles is all possible with a pencil at your fingertips. To make the layers work together, start with the base layer and draw the other layers one after the other, erasing any guides that you no longer need but leaving the suggestion of what may be beneath.

The number and type of folds will depend on the type of fabric and how tight or loose the garment is on the body. Thicker fabrics, such as the knits shown here, have fewer folds and just follow the outline of the body with simple lines and shading to give a little depth.

Here, a shirt, cardigan and jacket are all combined in one outfit. Start with the shirt on a simple torso and add each layer on top, keeping the body shape consistent.

MANGA ART SECRET

A ribbon bow is a popular accessory for female tops in manga art – it can be seen in the hair and on school uniforms, and is a common addition to most costumes. It is a slightly tricky shape to get right, so try drawing different bow shapes on their own, to make it easier to add one to an outfit as a finishing touch.

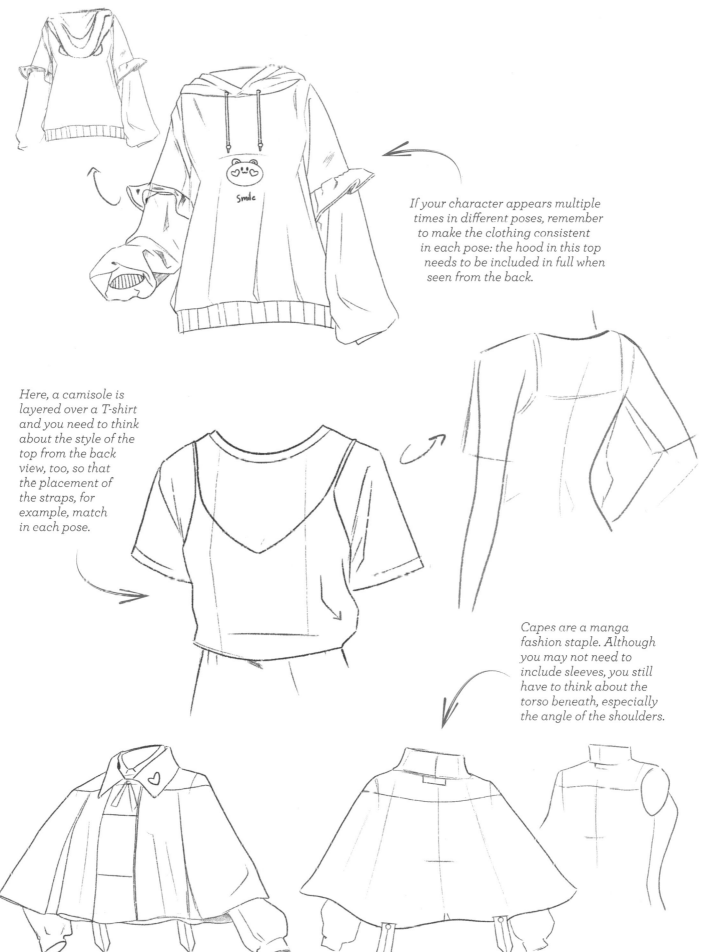

If your character appears multiple times in different poses, remember to make the clothing consistent in each pose: the hood in this top needs to be included in full when seen from the back.

Here, a camisole is layered over a T-shirt and you need to think about the style of the top from the back view, too, so that the placement of the straps, for example, match in each pose.

Capes are a manga fashion staple. Although you may not need to include sleeves, you still have to think about the torso beneath, especially the angle of the shoulders.

Smile

DRAWING TROUSERS AND SKIRTS

There are plenty of different styles to choose from for finishing your character's outfit with trousers, skirt or shorts. Whichever option you choose, start by drawing the legs accurately to give you an outline to follow and help to judge proportions and the basic pose as you add the fabric on top.

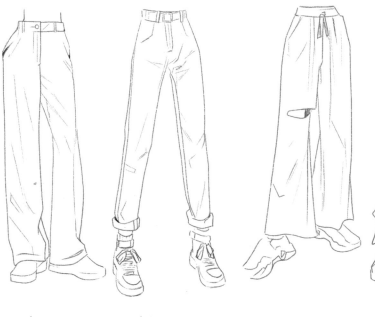

The silhouette of the legs will be more visible in tighter-fitting trousers, below, than in a looser fit, right, where the fabric will show more creases and folds. Don't forget pockets!

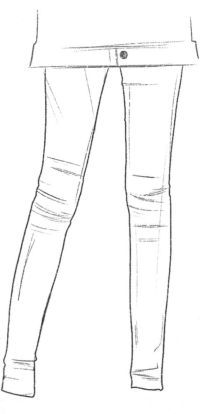

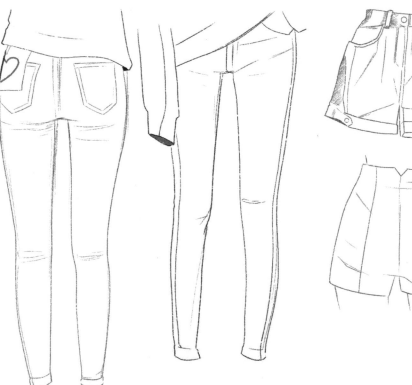

Skirt styles

There are many variations in skirt design and shape – long, short, pleated, full, tight or frilled – that you can select to suit your character. Try sketching out different styles, starting with an outline of the hips and legs, then adding the general shape. Look carefully at how the hemline reflects movement and think about the type of fabric, whether it is fluid like silk or stiff like denim.

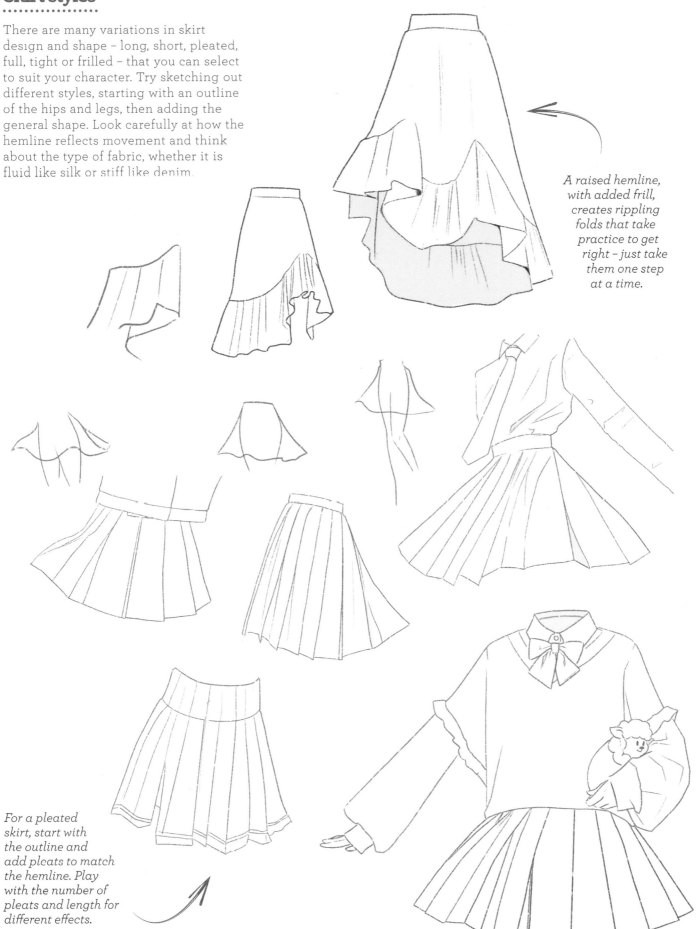

A raised hemline, with added frill, creates rippling folds that take practice to get right – just take them one step at a time.

For a pleated skirt, start with the outline and add pleats to match the hemline. Play with the number of pleats and length for different effects.

DRAWING DRESSES

A dress is the most popular manga costume. It can be formal or casual, contemporary or historical, or a combination of both. If your character is from an historical era, research the fashions of the time, taking elements that you like or copying the whole style. Add frills, bows and ribbons, and the look will be complete.

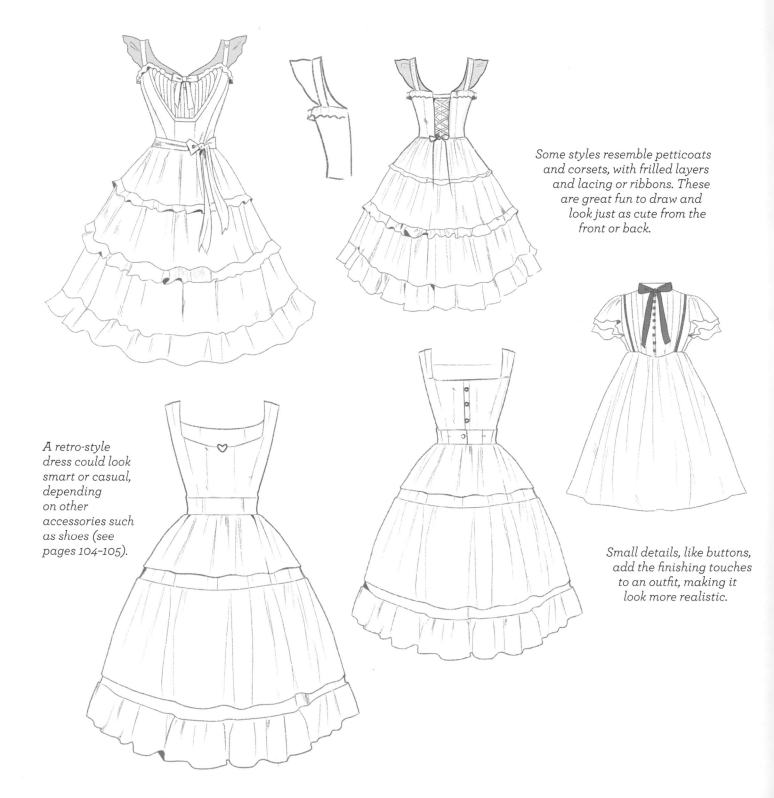

Some styles resemble petticoats and corsets, with frilled layers and lacing or ribbons. These are great fun to draw and look just as cute from the front or back.

A retro-style dress could look smart or casual, depending on other accessories such as shoes (see pages 104–105).

Small details, like buttons, add the finishing touches to an outfit, making it look more realistic.

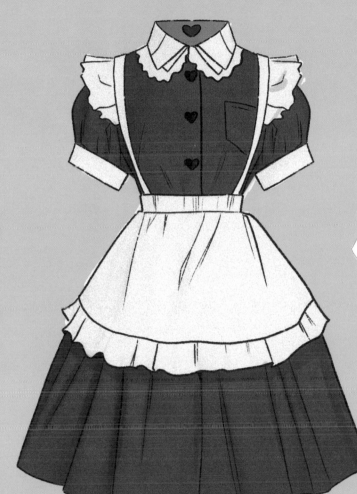

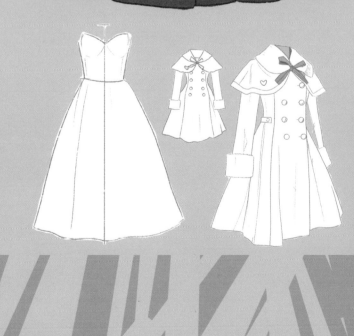

MANGA ART SECRET

One of the easiest ways to draw dresses is by thinking of them as if made up of two pieces – a top and a skirt. You can alter the design of either piece to come up with a new style for a dress.

HOODED SWEATSHIRTS

These are my favourite clothes type to draw – they make a character look fun, and can add an element of mystery, too. They are more straightforward to draw than some other tops, with just a single pocket and the hood to get right. A casual, unisex item, a hoodie instantly suggests a relaxed, youthful vibe.

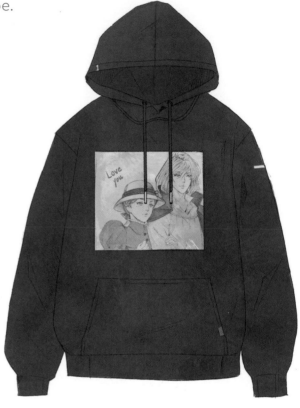

Because hoodies are usually quite big and loose on the body, they have a boxy shape that doesn't reflect the underlying torso in detail. Start by drawing the outline of the top, using a simple rectangular shape with arms, then add simple folds and the hood with drawstrings. To vary the style, you can play with design elements such as a pouch, logos, text or images, making the hoodie look unique.

When the hood is up, draw the head first and then add the hood around it so that they work together.

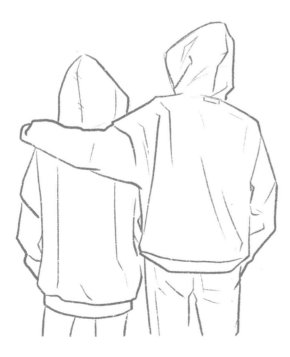

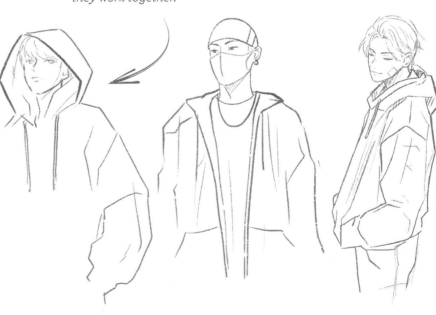

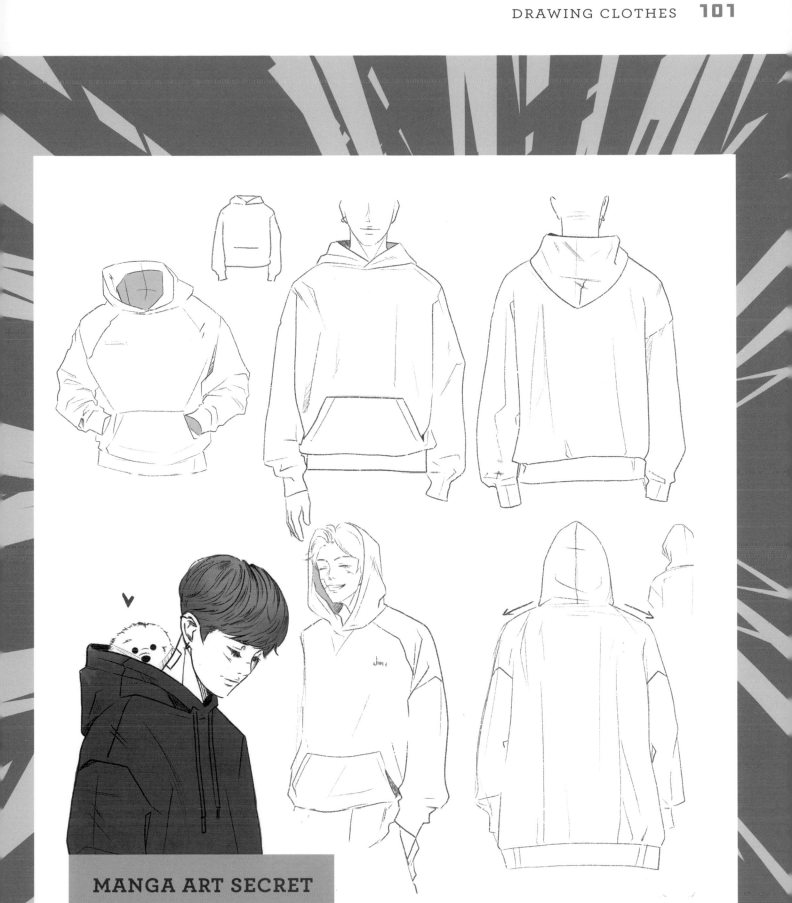

MANGA ART SECRET

Pay attention to the shape of the hood, as this is the element that changes the most when seen from different angles.

DRAWING SUITS

With its confident, assured and masculine overtones, a suit is one of the most common clothing styles used for male characters. Usually consisting of a jacket, or coat, a dress shirt, neck tie, dress shoes and trousers, the outfit is defined by crisp lines and a slender silhouette. Match a suit with a slick pose and you'll have it nailed.

For a well-tailored look, keep lines straight and angles crisp along the collar and shoulders.

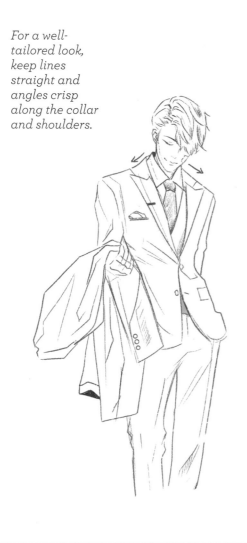

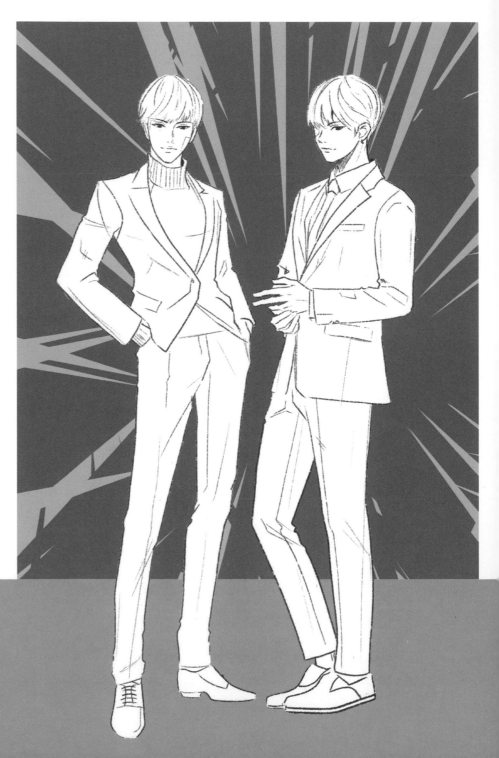

MANGA ART SECRET

Drawing the suit with a jumper, T-shirt or collarless shirt underneath the jacket makes the look more casual and comfortable, compared to the formal combination of a shirt and tie.

Draw each element of the outfit in stages, starting with the base layer. Practise drawing the layers separately before you combine them into one finished artwork.

Start by drawing the shirt and then the tie in full before adding the jacket, erasing the lower layers that aren't visible.

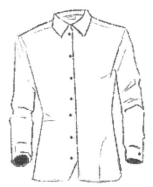

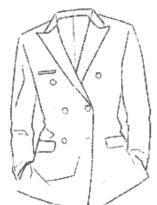

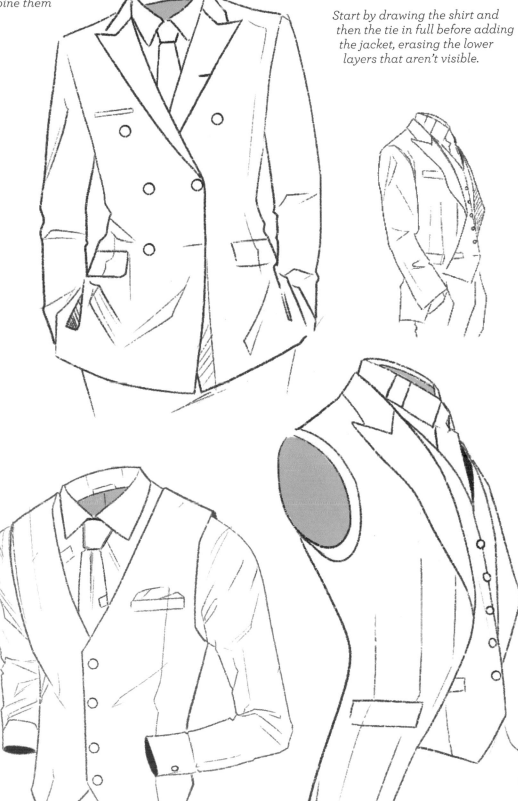

A waistcoat gives a very formal look and is often tailored to closely follow the shape of the torso.

DRAWING SHOES

The illustrations on these pages showcase the many different shoe styles that you can choose to add the final detail to an outfit. As in real life, there are hundreds of styles you can use for a manga character, from casual trainers to formal heels and dress shoes, and each adds to their personal look. Once the style is decided, start with the foot position and take it from there.

Drawing female shoes

1 Decide the shoe style. This helps you understand how the feet need to be drawn and their position in relation to the shoes; for example, stiletto heels raise the whole foot.

2 Sketch the feet. Estimate the placement of the feet depending on the pose (see pages 74–75). Take into account heel height and if the character is moving.

3 Add details. After finishing the main form of the shoes following the outline of the feet, add details such as a bow or shoelaces, depending on the style.

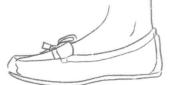

Drawing male shoes

To draw male shoes you simply follow the same principles as for female shoes, opposite, starting with the position of the feet, allowing for the height of the heel, then adding the particular shoe style on top.

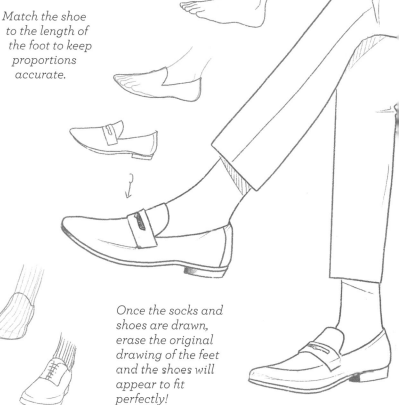

Match the shoe to the length of the foot to keep proportions accurate.

For socked feet, draw the socks on the feet first, then add shoes.

Once the socks and shoes are drawn, erase the original drawing of the feet and the shoes will appear to fit perfectly!

For detailed trainers, draw each part of the design separately.

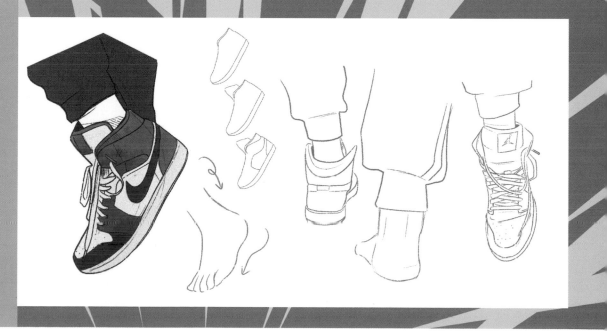

MANGA ART SECRET

Trainers tend to have more details and design elements than formal shoes. They are fun to draw, but take practice, so try sketching and combining different styles to make your character's footwear unique to them.

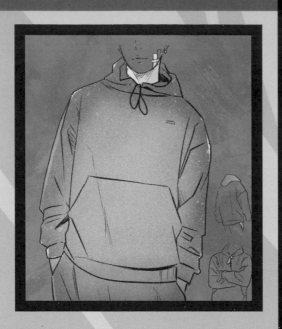

Follow these four simple stages to add a hoodie to your drawing, referring to pages 100–101 for more instructions on adding detailed touches.

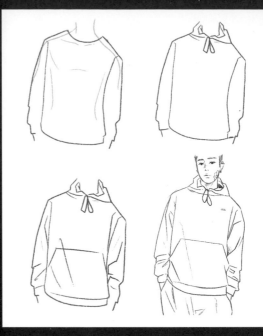

EXERCISE ROUND-UP

Clothing your character is often the final stage of your drawing, when you can add personality and individual touches. Filling a sketchbook with clothing ideas will help when you need to put an outfit together. Keep practising how to build clothes on the basic body shapes, using the body as a mannequin to add each layer of clothing, erasing base layers when they are covered with the final piece. Use these quick exercises to revise the stages, then design your character's wardrobe.

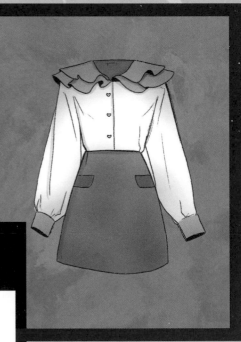

Whether a dress or top and skirt, use a dividing line to keep the shape symmetrical. See pages 94–99 for more on female clothes.

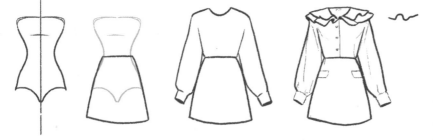

Starting with the position of the foot, draw shoes to follow the outline and pose. Running shoes can have complex uppers and soles, so build these slowly, adding as much detail as you wish but keeping the exterior shape correct and reflecting the feet inside. See more on shoes on pages 104–105.

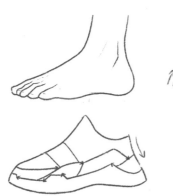
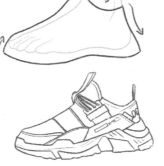

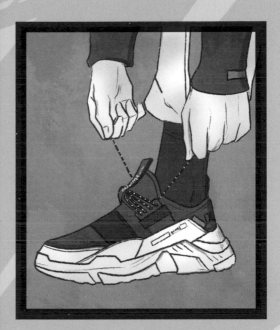

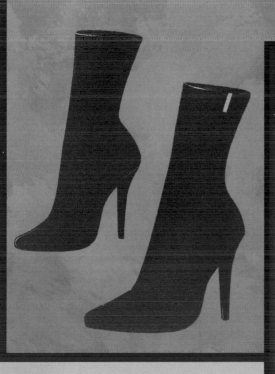

A high-heeled boot has a simple silhouette but it's important to mirror the height of the heel in the raised position of the foot. See page 104 for more female shoe styles.

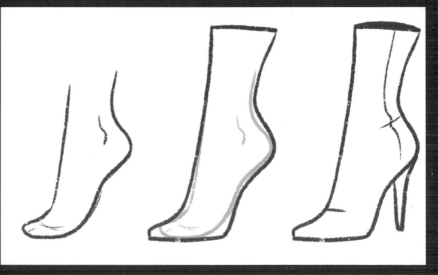

MAN FUNG (@L.MANFUNG)

Music and atmosphere are always my inspirations for creating my art. Thinking of those two factors allows me to get deep into my comfort zone and then I believe I can draw anything I want. People tend to think that spending a lot of time on a single drawing is the best method but, for me, every drawing has a time limit. If I think the moment has passed or the inspiration has faded, then I am not able to make the drawing any better, and might even make it look worse. So, my secret is to try to live and draw in the moment for every drawing and move on if it's not working.

MANGA ART SECRET

I create a colour palette before I start drawing, so I know which colours work together. I mostly use earth tones, but lately I have started to experiment with brighter colours.

DIFFERENT AGES

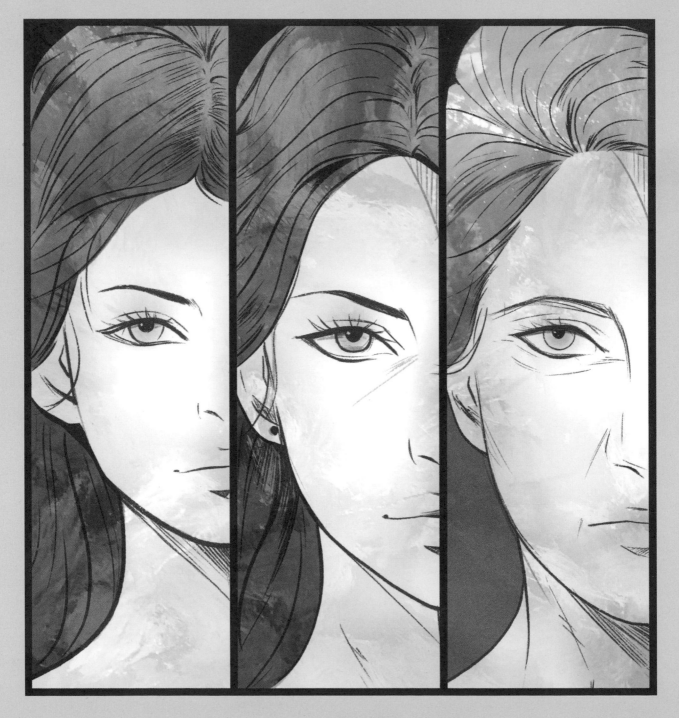

A final consideration that will affect your character's appearance is age. To help capture the different life stages, this chapter will look at the physical changes to the face and body which manifest in similar ways in a manga character as they do in real life. You can also use other indicators, such as clothing, hairstyles and accessories, to identify your character with a particular age group.

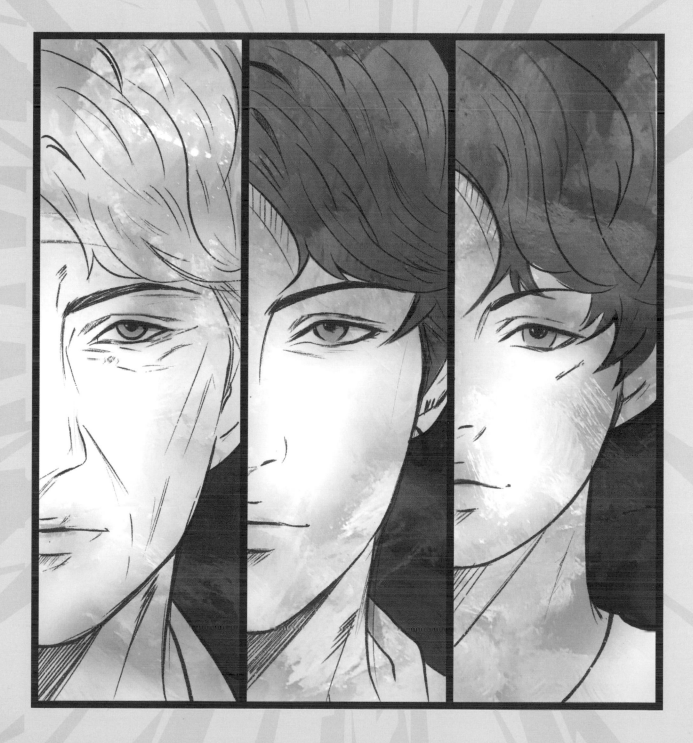

DRAWING CHILDREN: BOYS

An instant way to convey a young child is to draw the face much rounder compared to that of an adult. This, along with large eyes in a small face, makes them look cute and childish. Height and proportions need to be carefully observed in young children as they differ slightly to the adult body, and will change as a child grows. If drawing your manga character at different stages in their life, try to make some features consistent during each stage so they are still recognizable, such as the shape and colour of their eyes, or their hair colour and style. Use clothing, hair and poses to identify gender.

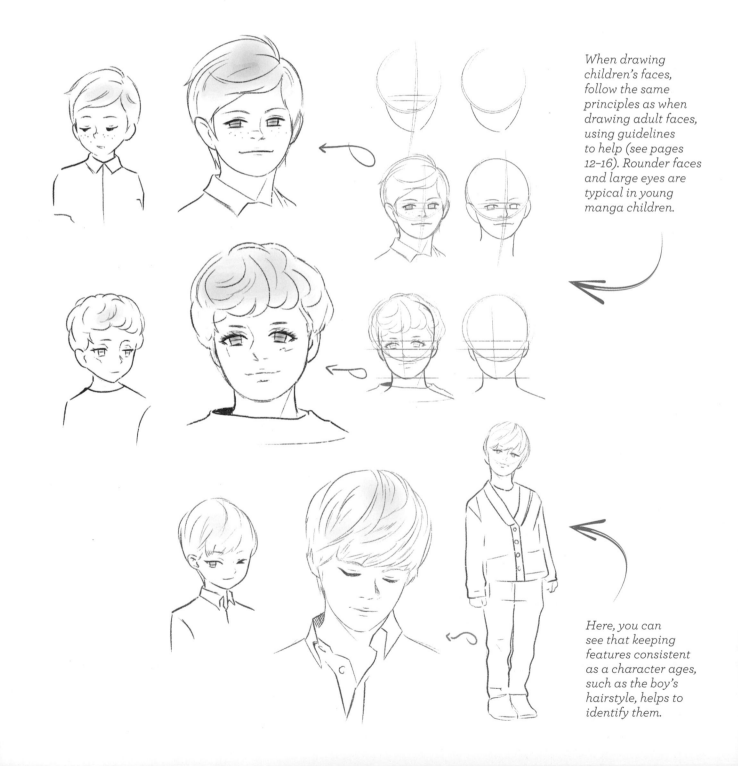

When drawing children's faces, follow the same principles as when drawing adult faces, using guidelines to help (see pages 12–16). Rounder faces and large eyes are typical in young manga children.

Here, you can see that keeping features consistent as a character ages, such as the boy's hairstyle, helps to identify them.

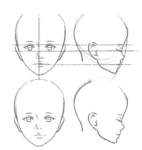

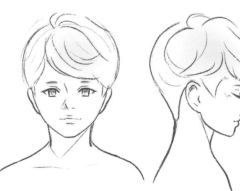

Use guides to keep features consistent in front and side views.

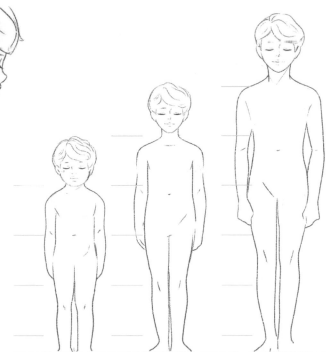

Growth stages

A child's height is a good indicator of their age. After the first year, a child grows steadily with more drastic changes to both height and body shape in the teenage years. Judge the proportions of a child in a similar way to adults (see page 59), using the head as a measure. Legs are shorter in young children, reaching adult proportions from about 12 years.

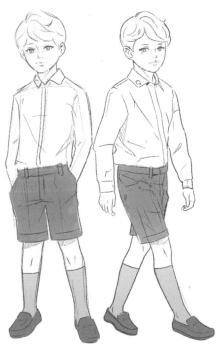

MANGA ART SECRET

Babies and young children tend to appear softer than adults in both their faces and bodies, with less muscle definition. This makes them look cute!

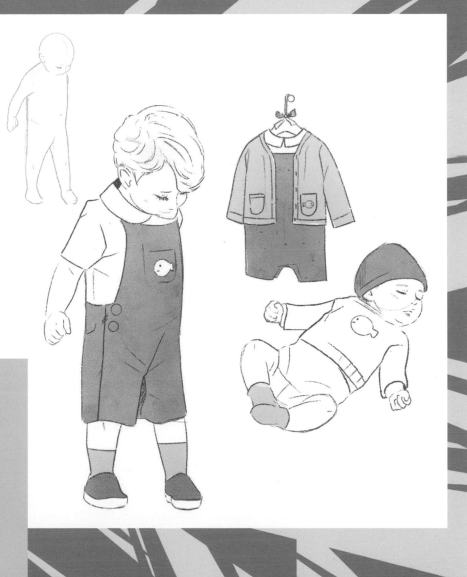

DRAWING CHILDREN: GIRLS

Much like real life, gender is not so pronounced between the shape of the body or in the facial features when drawing manga children, as compared to an adult character. Whether drawing girls or boys, the basic body shapes will be the same, so you need to use clothing and hairstyles to differentiate between the two; long hair is a common manga theme for girls. Another way to identify gender is to give your character traditional accessories and toys, such as dolls, to hold.

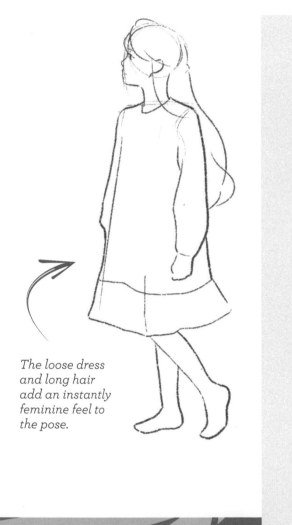

The loose dress and long hair add an instantly feminine feel to the pose.

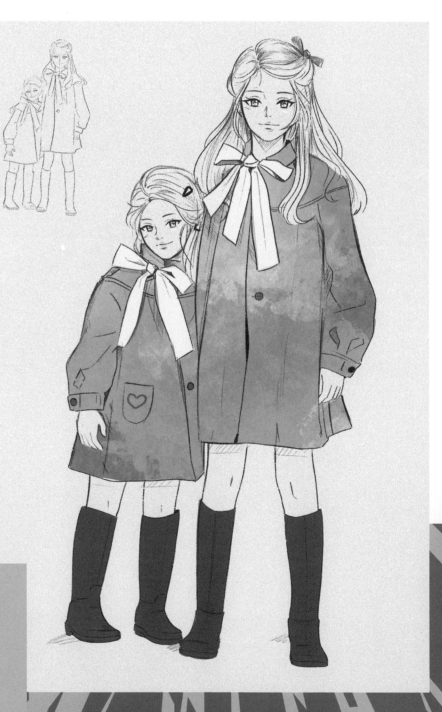

MANGA ART SECRET

When drawing siblings, it is a good idea to give them similar facial features and hair colour. You could also dress them in matching outfits, which is very common in manga.

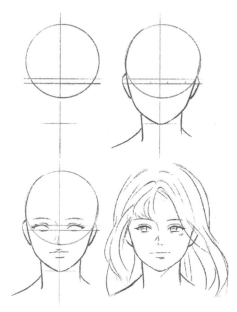

Follow the guides for adding facial features, making the eyes round and accenting the eyelashes (see pages 18–21).

It can be difficult to tell if a baby is a boy or a girl: use clothing and accessories, such as a cute doll, to help.

Young girl characters are often clothed in traditional-style dresses. Combine with a whimsical pose to capture manga style.

DRAWING TEENAGERS: BOYS

Drawing male teenagers follows the same basic principles as drawing male bodies (see pages 70 and 80), where the rounded, childish features give way to a more defined and slimmer body shape. Despite looking like an adult male, you can give your teen character a sense of freedom and youth by using different styles in clothing, hair and accessories and matching them to casual and fun poses.

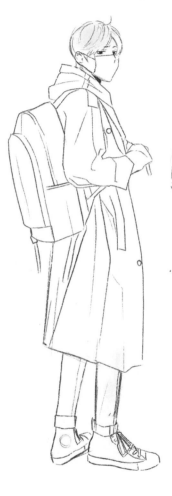

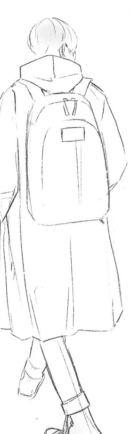

A backpack is a teen accessory that adds casual style to any pose.

A sporty character opens up many different options.

Teen style

Take your inspiration for manga teen clothing from teenagers in real life. They tend to favour more casual clothes than adults might wear, and hoodies feature more frequently. Sports clothing and school uniforms are also good styles to use to indicate a more youthful character, along with longer and sometimes bolder hairstyles. Nonchalant and relaxed poses are also key to a teenage vibe.

Male teenagers in manga style tend to be as tall as adults, with similar muscle definition.

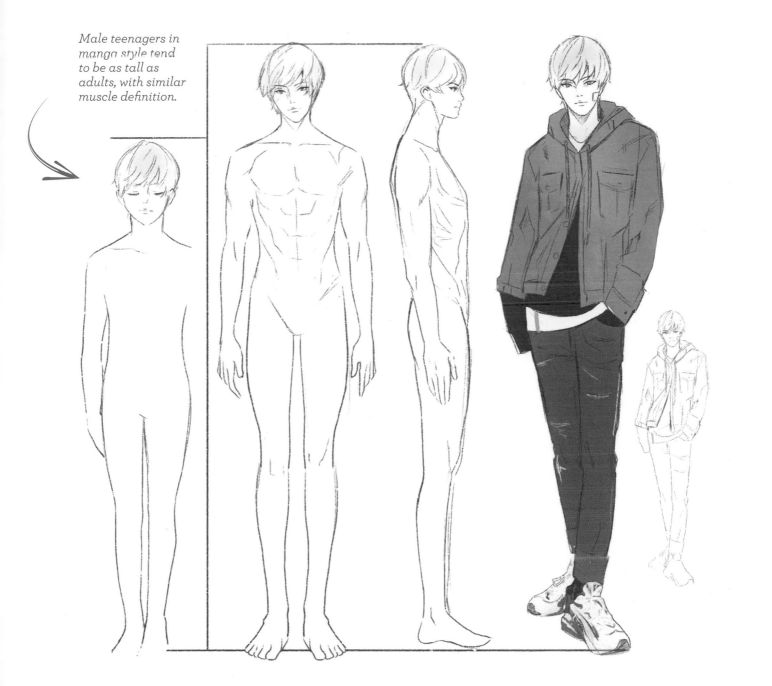

MANGA ART SECRET

Teenage boys have a more defined jaw than boy children. If you are showing a character that you have drawn as a child, keep a similar hairstyle and eye shape, but add a sharper jaw and slimmer face as they mature.

DRAWING TEENAGERS: GIRLS

In manga style, female teenagers have a more mature, adult look in their bodies and facial features than teens in real life. It is through clothing, hairstyle, make-up and accessories that you can give them a youthful edge, using outfits such as school uniforms for characters under the age of 18. Have fun with hair, too, with pigtails and plaits adding cute undertones.

Small touches, like a bag or books, makes a school uniform look realistic.

Female teenagers match the same proportions as adults with similar body shapes (see pages 58–59).

Accessories

Teenage girls in manga tend to have a lot of accessories and these are often bolder and cuter than adult versions. Bows, hats, hair accessories, socks and bags are fun to experiment with to give your drawings life.

Socks, hats, pigtails and bows all combine in a cute and fun look.

Teenagers are never far from a phone! Use these and other accessories to add to your character's persona.

Certain poses show youth and energy that are more often associated with teenagers than adults. Make use of a pose full of vitality when drawing teens – dancing, jumping or just fooling around!

GROWING UP

In these illustrations, you can see how factors such as the style of hair and clothes, affect our perception of how old a character is. With a change in outfit, the casual teenager can be transformed into a formal adult. Much easier than real life!

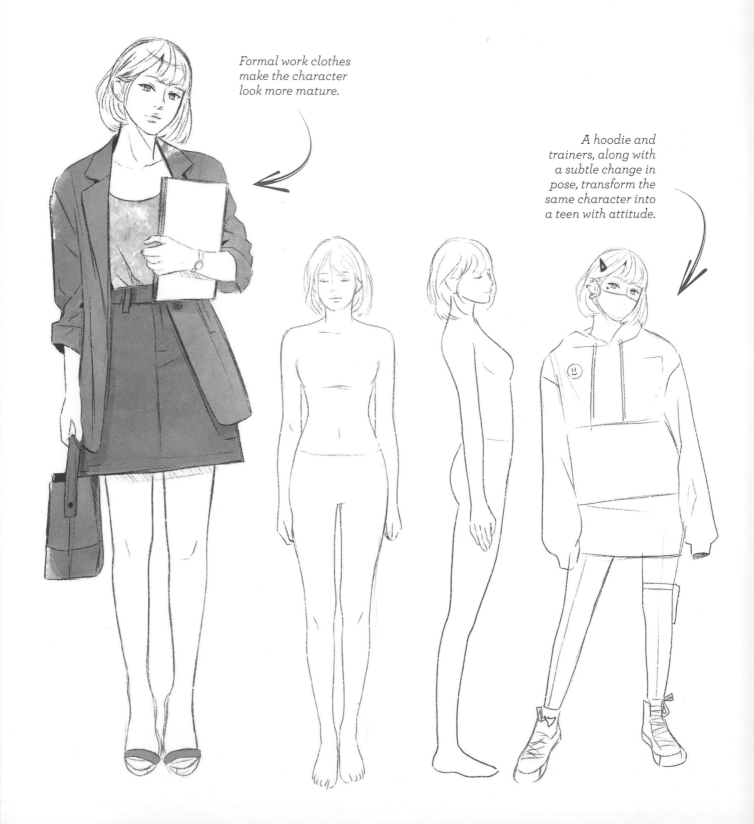

Formal work clothes make the character look more mature.

A hoodie and trainers, along with a subtle change in pose, transform the same character into a teen with attitude.

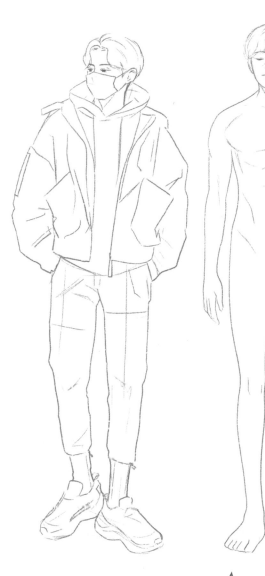

Casual clothes make the character look more full of life and youthful.

A formal suit gives a confident and grown-up style.

DRAWING OLDER PEOPLE

The progress of time has effects on our appearance that you need to reflect in your manga characters as they age. In later life, our bodies change shape, our hair thins and greys, and a few lines and wrinkles appear. Although these changes aren't so pronounced in manga drawings, try to capture some of the key features to make your character more believable as an elderly individual.

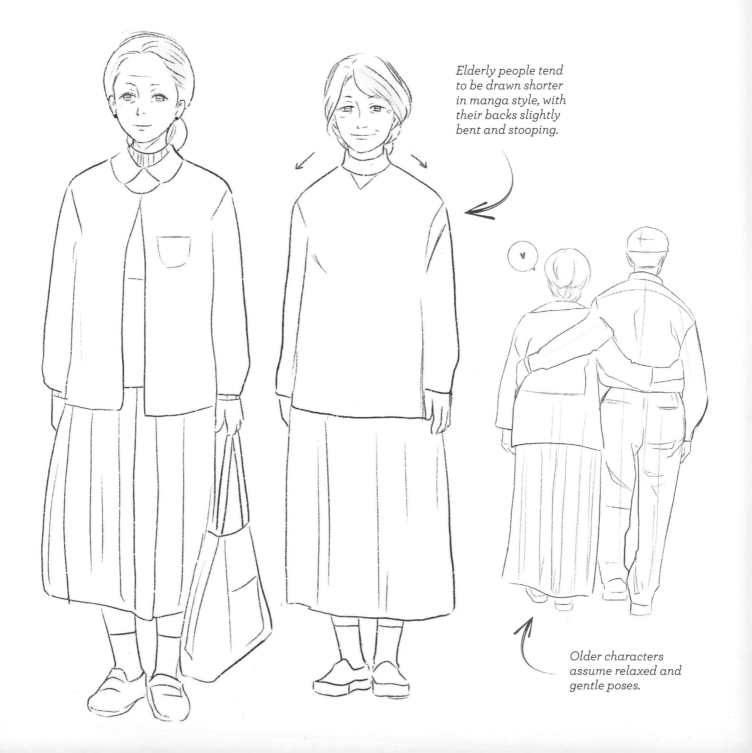

Elderly people tend to be drawn shorter in manga style, with their backs slightly bent and stooping.

Older characters assume relaxed and gentle poses.

The style of clothes becomes a little more modest and comfortable, with looser silhouettes. Hair may be thinner and recede.

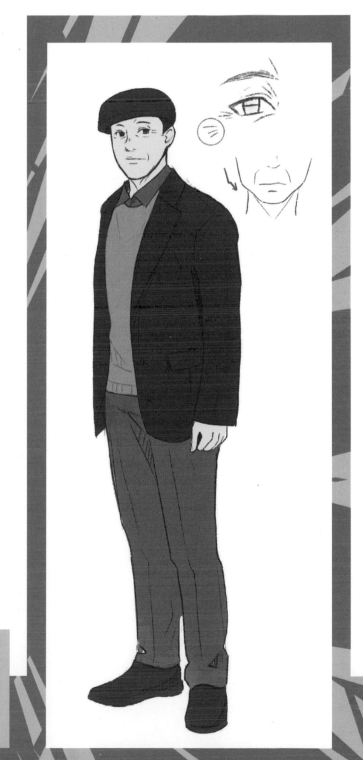

MANGA ART SECRET

Adding wrinkles around the eyes and mouth is an effective way to show ageing in manga style.

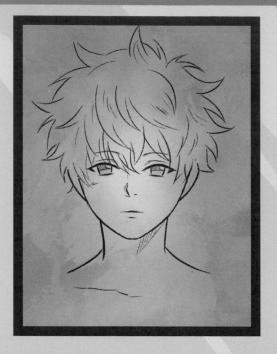

In young children, the head is rounder and eyes larger. Use guides to position the features (see pages 12–13).

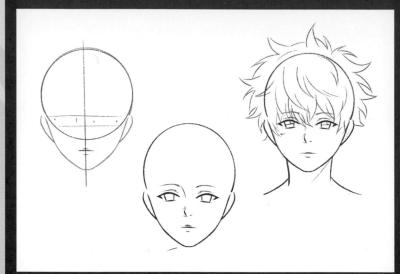

EXERCISE ROUND-UP

Now that you have drawn each life stage, it's time to go back and practise the techniques and styles that match the different ages. You can use these exercises to draw one character throughout their life, or experiment with changing certain features to draw several characters. These exercises focus on the head and hair, but revisit sections on the body and clothes to complete the look.

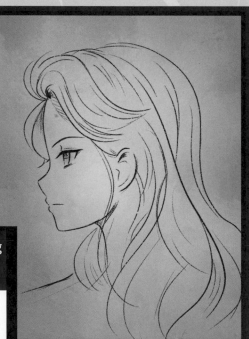

For teen girls, make a feature of long hair and think about adding accessories or different styles (see also pages 46–51).

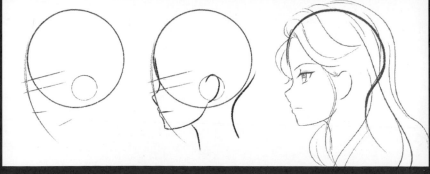

As boys mature their facial features become more defined, with angled cheeks and chin. Long, layered hairstyles add to the look. See pages 116–119 for more teen styles.

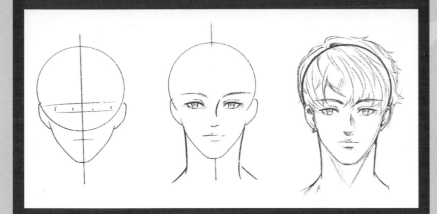

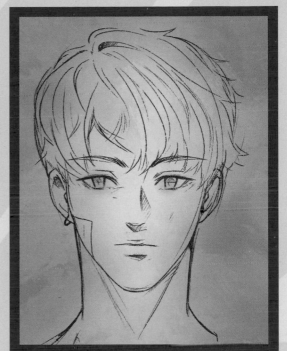

For an older character, the face is smaller and rounder, with a few creaselines around the eyes and mouth as signs of the passing years.

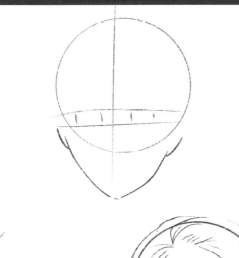

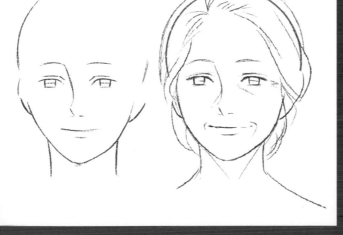

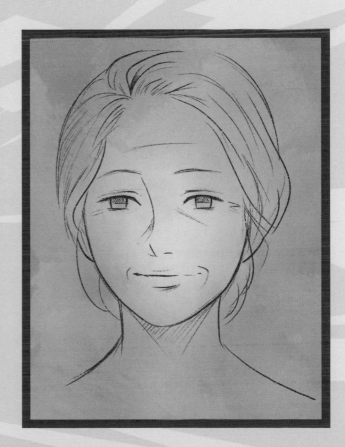

INDEX

ACKNOWLEDGEMENTS

I am so thankful for all the people who played a role in making this book happen. I am really grateful to my family for their support, especially to my parents who kept cheering me on so I could develop confidence in my drawing abilities from a young age. I appreciate the help my brother Wael and twin sister Diana gave me while I was working on this book. Thank you to my followers on Instagram for showing interest in my drawings and for all of their support. Special thanks to Kate, Anna, Martina and all the team at Quarto, who made this book happen. I am grateful to all of the artists in residence who allowed us to use their wonderful work in this book. It was an honour for me to create this book and I am so happy that I was given the opportunity to achieve one of my biggest dreams.

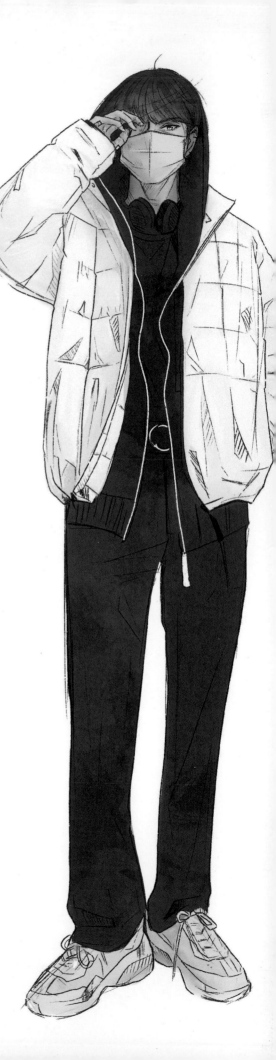